VILLAGES
AROUND
COLCHESTER
THROUGH TIME
Patrick Denney

AMBERLEY PUBLISHING

Acknowledgements

I am indebted to a number of people who have provided me with valued help and assistance in compiling this book. Firstly, I would like to acknowledge the help I received from the late David May who generously provided me with free access to his large collection of local photographs. My thanks are also due to Brian Jay who provided me with numerous pictures of Mersea and the surrounding villages, Mike Davis for his picture of the Strood in flood, Stephen Denney for pictures of Mersea and Peldon, Glen Jackson for pictures of Wivenhoe, Aldham & Great Tey, John Morse for pictures of Layer de la Haye and John Norman for numerous other contributions. Finally, I would like to thank Daphne Allen and Greta Buy for help in compiling some of the textual comments for the Fingringhoe section.

For Joe Denney

First published 2010

Amberley Publishing Plc
Cirencester Road, Chalford,
Stroud, Gloucestershire, GL6 8PE

www.amberley-books.com

ISBN 978 1 84868 566 6

British Library Cataloguing in Publication Data.
A catalogue record for this book is available from the British Library.

Typeset in 9.5pt on 12pt Celeste.
Typesetting by Amberley Publishing.
Printed in the UK.

Contents

Acknowledgements 2

Introduction 4

CHAPTER 1 Abberton, Langenhoe & Peldon 5

CHAPTER 2 Aldham, Fordham & Great Tey 13

CHAPTER 3 Ardleigh & Dedham 21

CHAPTER 4 Alresford, Elmstead & Frating 31

CHAPTER 5 Boxted & Great Horkesley 39

CHAPTER 6 Brightlingsea 47

CHAPTER 7 Fingringhoe & Rowhedge 53

CHAPTER 8 Layer de la Haye 65

CHAPTER 9 Mersea Island 71

CHAPTER 10 West Bergholt 83

CHAPTER 11 Wivenhoe 89

Introduction

The village communities of north east Essex share a rich and varied history. Most can trace their origins back to the time of the Domesday survey and beyond and all have played a significant part in both our local and national heritage. The present compilation of photographs, however, concerns itself with more recent times, particularly from the late Victorian period onwards when early photographers were busy recording everyday life and events in the area. From the picturesque villages surrounding Colchester to the coastal regions of Brightlingsea and Mersea Island, the book explores the changing scenes of life in these rural and small town communities. Street scenes, buildings, transport and fashions are all graphically recorded and serve to highlight the ever forward march of time.

More than ninety specially selected archive images have been matched with a similar number of contemporary photographs in full colour throughout. This not only provides a pleasing aspect as each page of the book is turned, but also serves to highlight and magnify the changes that have been made over time. In some cases these changes have been slow and hardly noticeable, whereas in others the pictures reveal communities that have altered and developed almost beyond recognition. The images are accompanied by well researched captions providing a wealth of information relating to the subject matter being presented. The compilation will serve as a nostalgic reminder to those who can remember life as it used to be in the rural communities, and will also add to the knowledge and enjoyment of all those who take an interest in this part of north east Essex.

Patrick Denney
March 2010

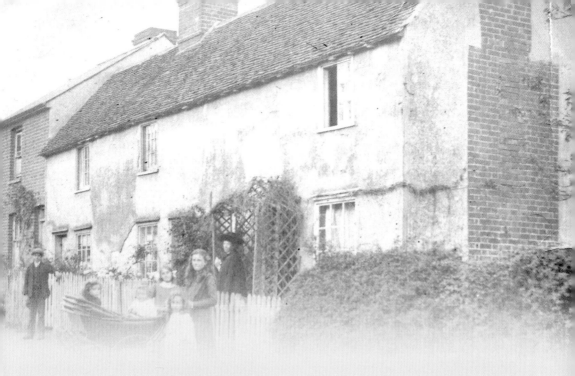

CHAPTER 1

Abberton, Langenhoe & Peldon

(Cottages on Colchester to Mersea Road)

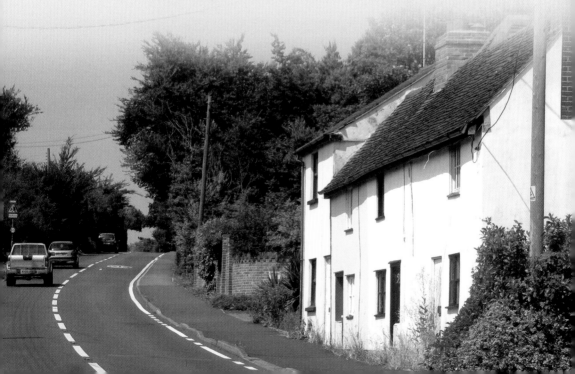

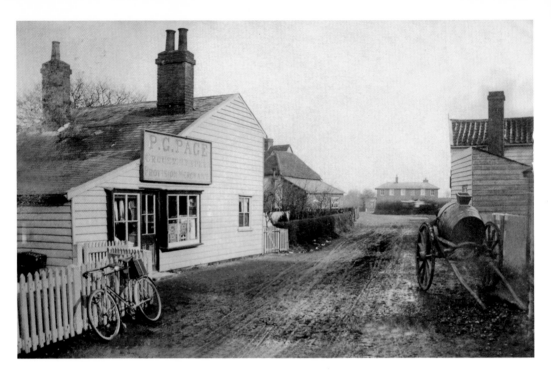

Abberton – To fetch a pail of water

This picture, from 1906, was taken in Layer Road, Abberton, looking towards the Langenhoe Lion public house which can be seen in the background. Note the water cart on the right of the street which was used to deliver drinking water to many of the households in the area. The water was sold for about a halfpenny a pail and was collected from a spring near the Whalebone public house in Fingringhoe. The modern view is from 2010.

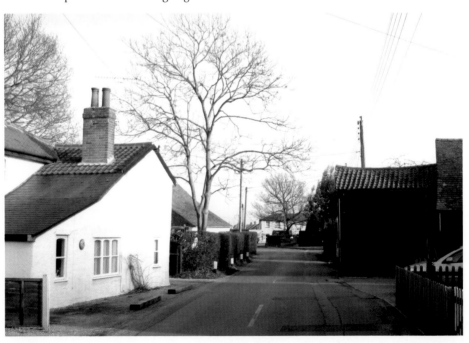

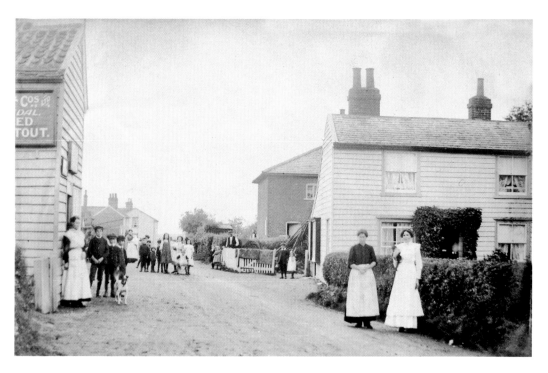

Abberton – village people

Another view of the same street, but this time looking in the opposite direction. The picture dates from the early 1900s and would appear to have been carefully planned with everyone standing in their set positions.

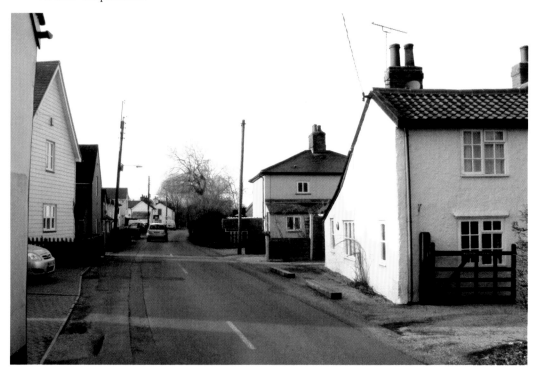

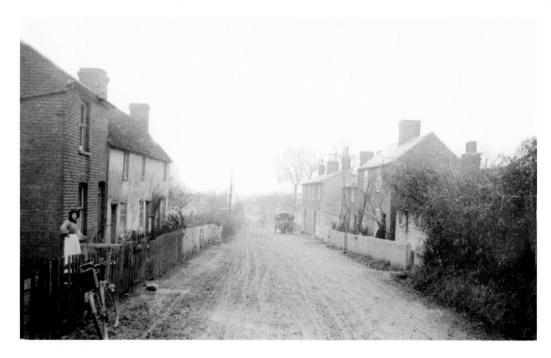

Abberton & Langenhoe – roadside cottages
One would hardly recognise this as being the main road leading from Colchester to Mersea. The cottages on the left side of the road still remain, whereas those on the right have long since disappeared. Note also the muddy road surface compared with the modern tarmac version from 2009. (See also the picture of cottages on page 5)

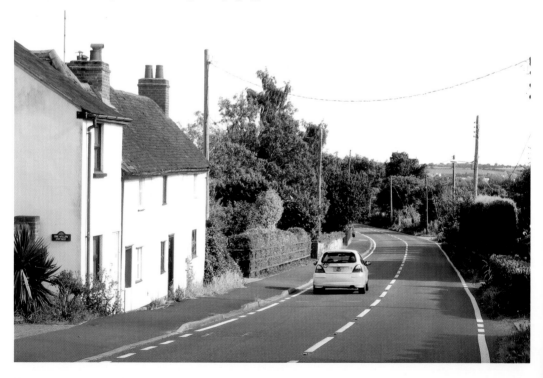

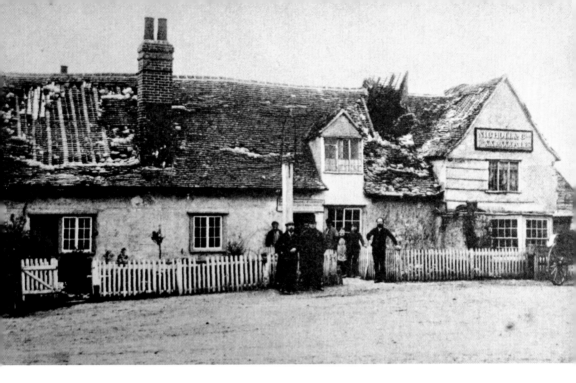

The Peldon Rose

The picturesque Peldon Rose Inn is situated just on the mainland side of the causeway which leads across to Mersea Island. When smuggling was rife along the Essex coast, the inn is said to have been a haunt for local smugglers who reputedly used to hide their booty from the excise men in the adjacent pond. In 1884, at the time of the Great English Earthquake, the building suffered severe damage and was nearly wrecked. The quake, which was centred on the surrounding countryside, was felt as far away as Somerset in one direction and Ostend in the other.

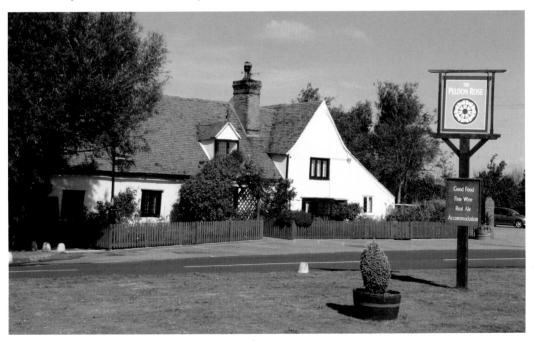

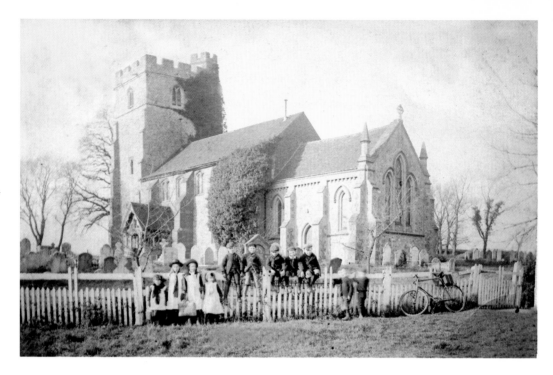

Peldon Church

This group of children are lining up for a photo shoot in front of St Mary's church, sometime around 1912. The church is of Norman origin, although additions have been made to the building throughout the centuries. The church was much restored in the late 1850s when a new chancel was added as depicted on the earlier picture. However, due to the effects of the earthquake of 1884, and the general unstable soil conditions of the area, this chancel was later considered unsafe and replaced with the present structure in 1953.

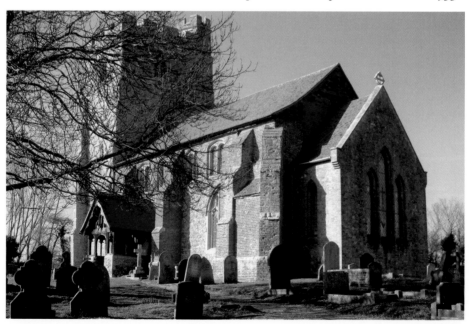

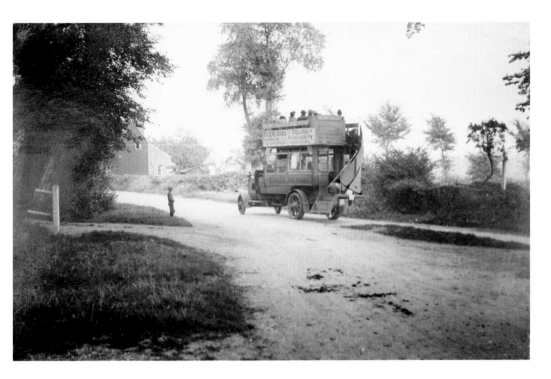

The Mersea bus at Peldon

This open-top bus, *en route* to Abberton, is seen passing the junction once known as Hyde Park Corner in 1922. The service was part of the Colchester-Mersea route which was first set up by Arthur Berry in December 1904. Berry's first motor bus used on the route was a 10-seater Daimler which was driven by Arthur himself, with his young son Stanley collecting the fares of 1/4d (7p) return. As is seen from the modern view, buses operating between Colchester and Mersea still pass through the village.

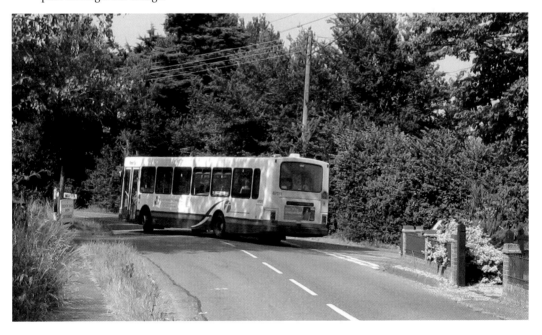

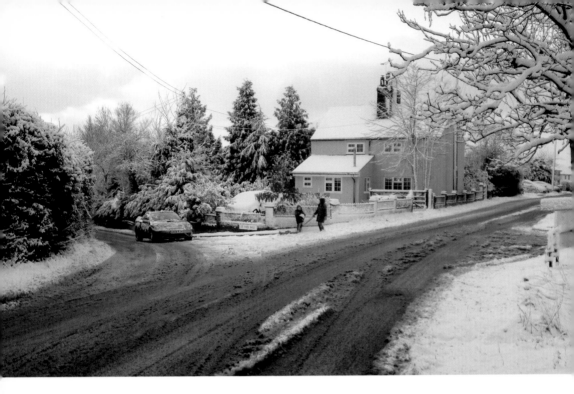

Hyde Park Corner, Peldon
This winter scene, taken at the same junction, looks back along Church Road in the direction of Great Wigborough. The earlier view dates from the 1930s.

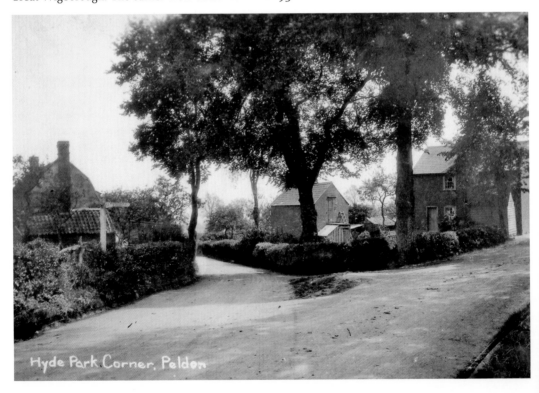

Hyde Park Corner, Peldon

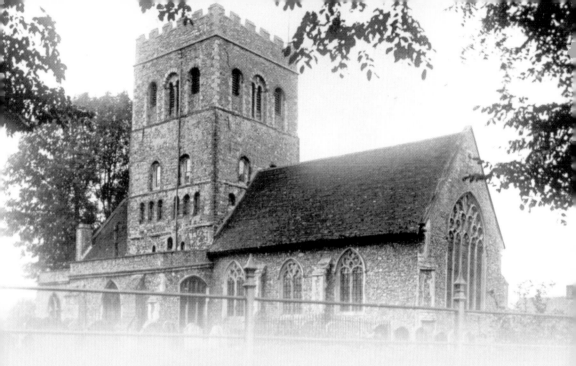

Aldham, Fordham & Great Tey

(St Barnabas Church, Great Tey)

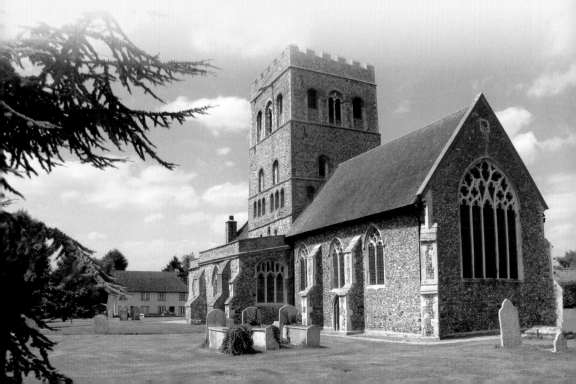

Ford Street, Aldham

This charming view of Ford Street, Aldham, dates from the early 1900s. The street is clear of traffic with just a few pedestrians present. The workman on the left has halted momentarily from his labours, while the smartly dressed couple on the right seem happy to pose for the photographer. The modern view from 2009 shows that over a century later the street still retains its old-world charm.

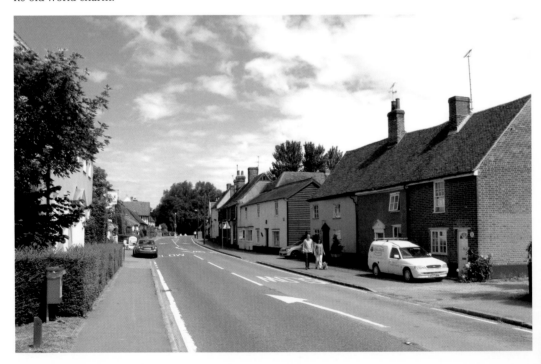

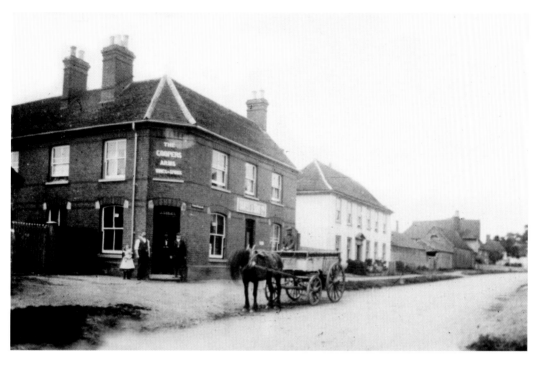

The Coopers Arms

Another view of Ford Street showing the Coopers Arms public house. This local hostelry dates from at the least the seventeenth century when, in 1671, it was known as the Kings Arms. By 1725, it was trading as the Queens Arms, and by 1845, according to Kelly's directory, the Coopers Arms.

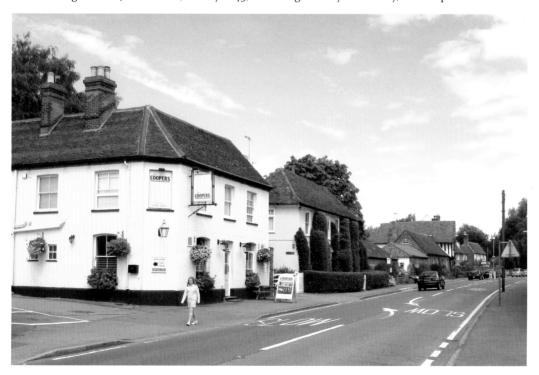

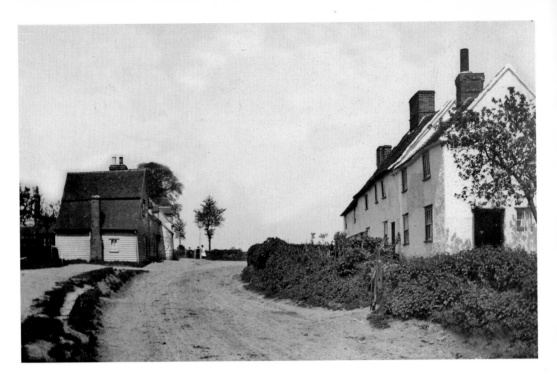

Church Road, Fordham

This scene, from around 1910, was taken in Church Road, Fordham, looking towards the Three Horseshoes public house seen on the left. The building on the right of the street is known as Oak House and dates from the seventeenth century when it was two separate buildings. At the time of the 1881 census, however, the building was divided into four separate dwellings and described as 'The Old Workhouse'.

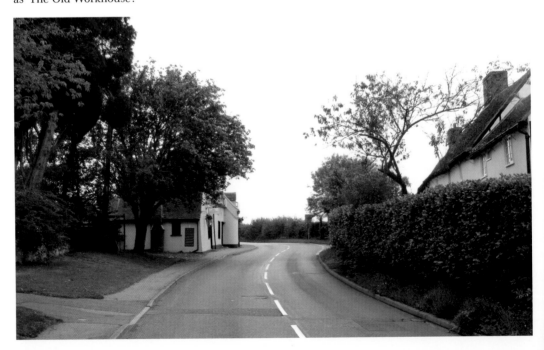

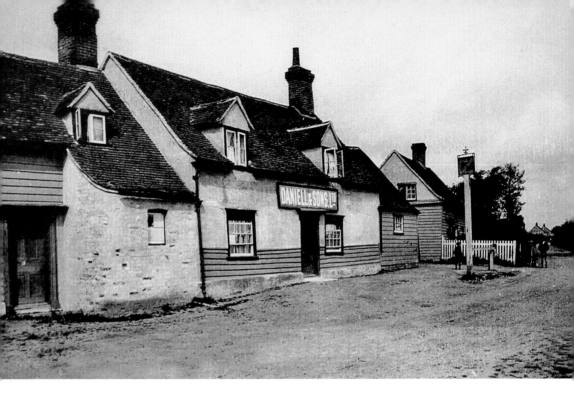

The Three Horseshoes – Fordham

The Three Horseshoes public house occupies what was originally two separate timber-frame buildings dating from the early sixteenth century. The pub is first mentioned by name in Kelly's directory for 1866 with the proprietor, Oliver Bull, being described as a Blacksmith & Miller. In 1874, the pub gained some notoriety when an inquest was held on the premises, following the brutal murder of Solomon and Susannah Johnson by their deranged son Thomas. The modern view of the building is from 2009.

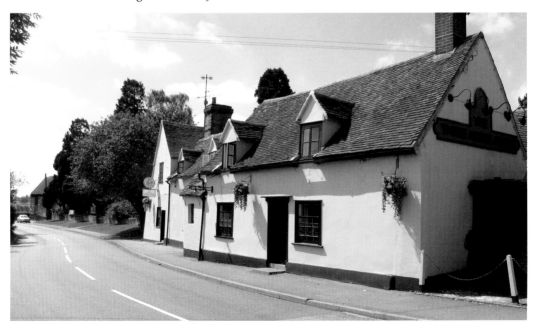

Fordham War Memorial

Here are two views of the junction at Church Road and Ponders Road. The main difference between the two images, apart from having been taken about ninety years apart, is the small war memorial seen standing by the garden wall in the modern picture. The memorial, which was erected in 1919, lists the names of twenty-two Fordham soldiers who lost their lives during both world wars.

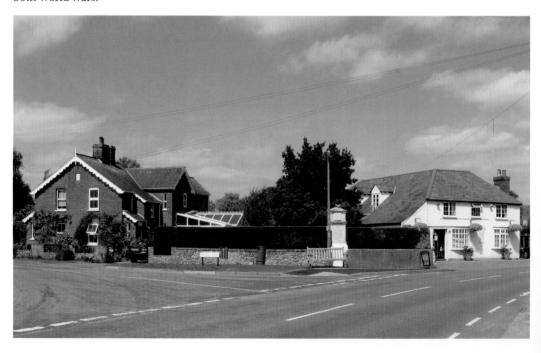

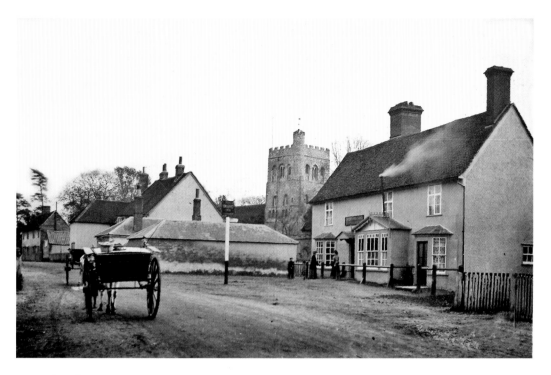

The Chequers – Great Tey

The Street, Great Tey, looking east towards the Chequers public house and St Barnabas church, in the early 1900s. The Chequers is thought to have been established as far back as 1660, although the building itself may be even older. Note the horse and carts standing in the street outside the pub. Perhaps their drivers have been tempted to take a quick break in the inn opposite. The modern view from 2009 shows that very little has changed in the intervening years.

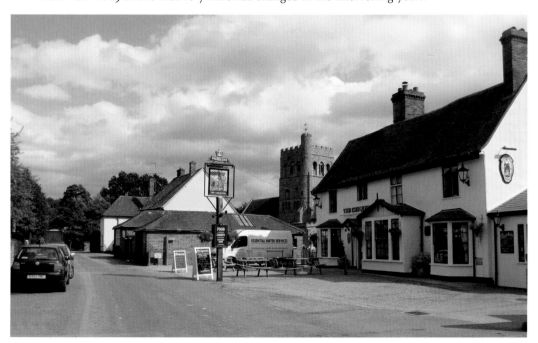

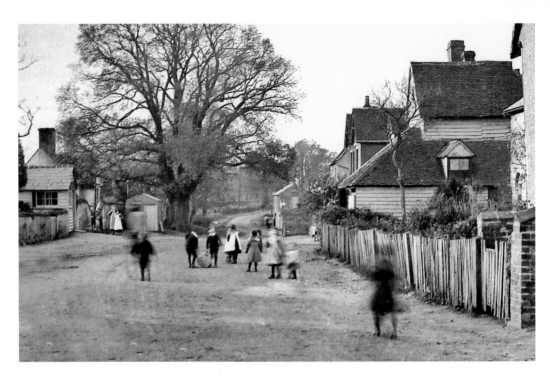

The Street – Great Tey

In this view of the same street, we are looking in the opposite direction, with a group of children congregated in the middle of the road. Before the advent of modern motor traffic the streets of many rural communities often took on the role of extended playgrounds where children could happily wander around without putting themselves in any real danger. In modern times, however, the rules have changed and even in seemingly quiet rural areas most children confine themselves to much safer play areas.

CHAPTER 3

Ardleigh & Dedham
(St Mary's Church, Dedham)

Dedham Road, Ardleigh and Church

In this street scene of Ardleigh, taken in 2009, we are standing at the junction of the Colchester and Harwich Roads and looking north towards St Mary's church and the road leading to Dedham. In the older picture we have a much clearer view of the church, which, although still retaining its late fifteenth century tower and porch, is largely of Victorian construction.

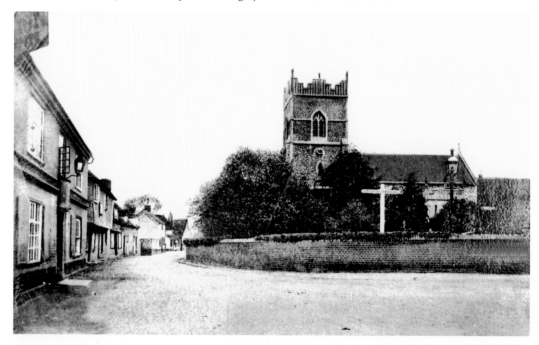

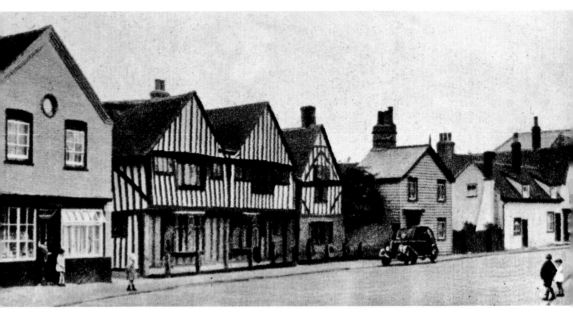

The Ancient House, Ardleigh

One of the oldest houses standing in the main street of Ardleigh is the triple-gabled building known as the Ancient House. The building is thought to date from the fourteenth century and was formerly known as the King's Head public house until its closure in 1919. In recent times the building has been used as a restaurant and brasserie, but has now been converted into two private dwellings.

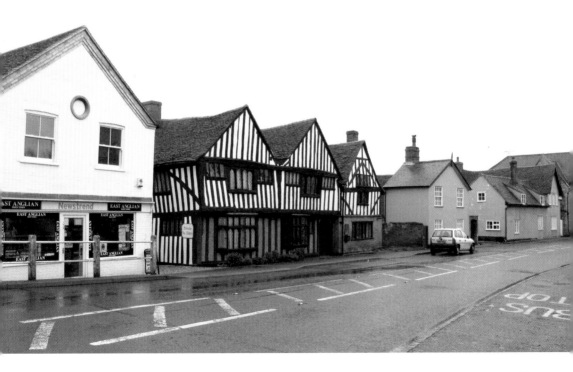

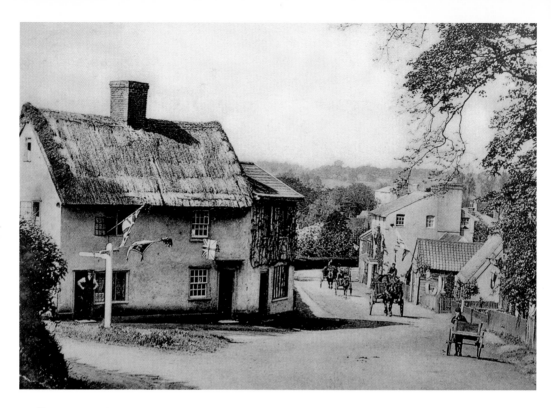

Dedham – view from Shoebridges Hill

This charming and tranquil scene of Dedham, dating from the early years of the last century, is seen from a position on Shoebridges Hill near to the junction with Stratford Road. Note the union jacks flying from the house on the corner which may indicate a national event being celebrated at the time. Despite the obvious difference in the modes of transport depicted, the scene remains very much unaltered.

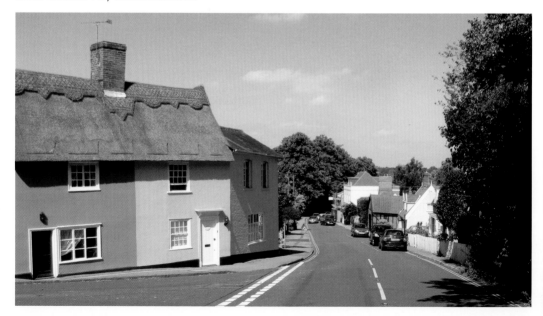

Dedham – river views

Here we have two contrasting views of the River Stour at Dedham. The left hand bank forms part of the county of Suffolk, whereas on the right side of the river, you are in Essex. The earlier of the two views, which dates from around 1920, was taken from the Mill Pool looking downstream towards the present road bridge. The modern view was taken from the road bridge looking further downstream towards Flatford Mill. The view has a calming feel about it with cows, rowing boats and walkers all adding to the tranquillity of the scene.

Dedham High Street looking east

This view shows the High Street, Dedham, looking east towards the former Congregational church seen rising above the trees on the right. The church was built in the early 1870s and was converted into an arts and crafts centre in 1984. With the exception of the gabled building, the houses lining the left of the street are mainly of timber-frame construction with later Georgian brick façades. The modern view is from 2009.

Dedham High Street looking west

In this picture of Dedham High Street we are looking west towards the War Memorial and St Mary's church. The row of buildings extending along the right of the street provides an impressive architectural prospective to this historic community.

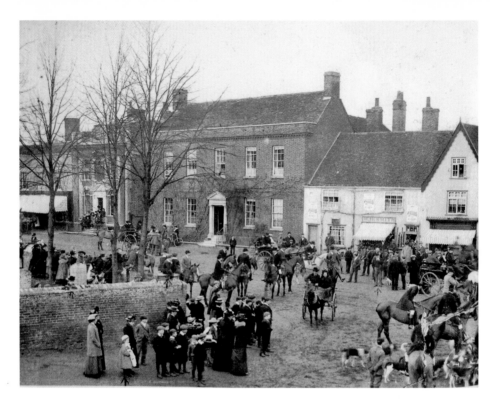

Meeting of the Hunt

In this view of Dedham High Street, from 1911, crowds can be seen congregating by the Royal Square for a meeting of the hunt. The building on the right of the view is Smith's General Stores; adjacent is Ivy House and just visible through the trees is a group of children standing on the front steps of Sherman's Hall, which by this time was being used as a school for girls. In the modern view from 2009, Ivy House can be seen half covered with foliage.

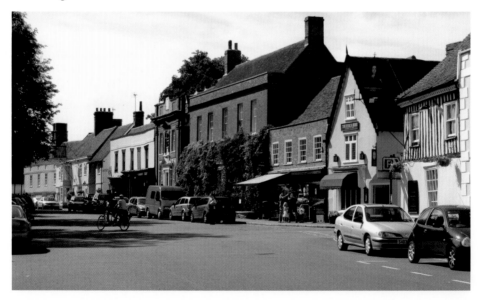

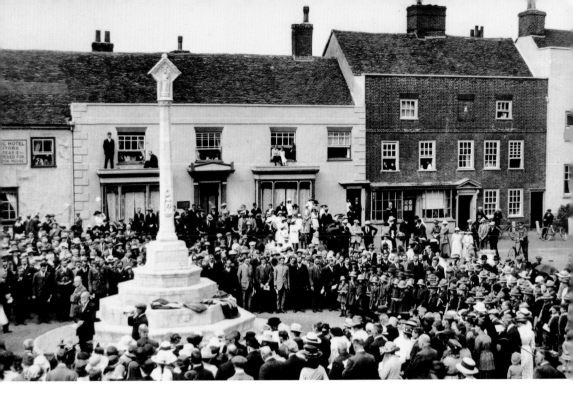

The War Memorial

This picture shows a service taking place in front of the War Memorial, Royal Square, in 1922. A large crowd is in attendance including a number of people occupying various vantage points on nearby buildings. In the modern view the scene is a little more relaxed with the steps of the memorial providing a resting spot for visitors.

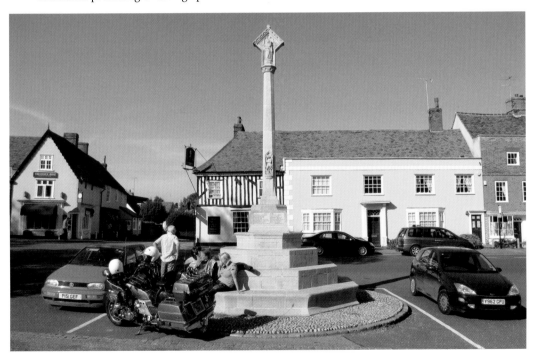

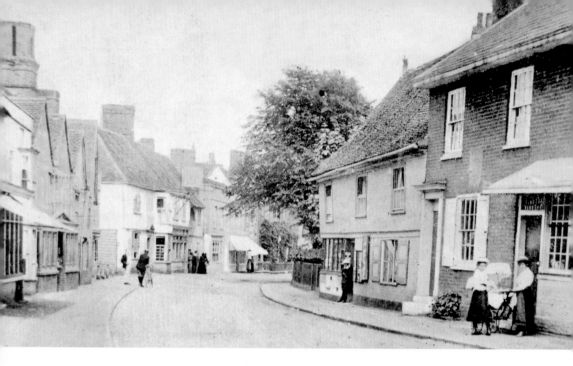

Dedham – Edwardian view

This Edwardian view of Dedham High Street is seen looking east towards the Royal Square from a position near the Sun Inn, seen just past the gabled building on the left. The modern view, from 2009, shows how the village has retained much of its architectural heritage, attracting thousands of visitors to the area each year.

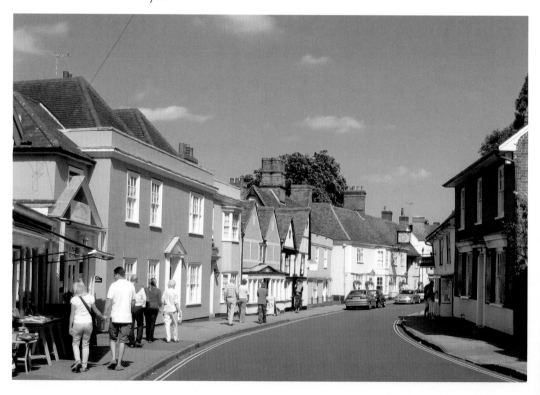

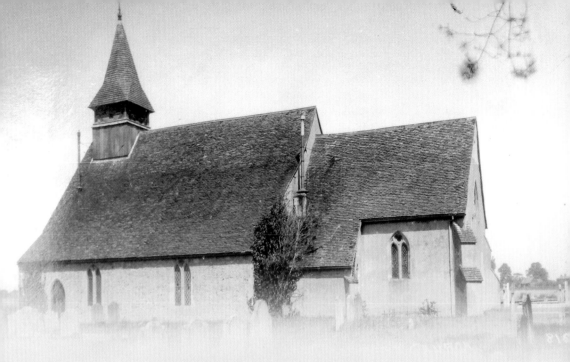

CHAPTER 4

Alresford, Elmstead & Frating

(St Peter's Church, Alresford and its ruins)

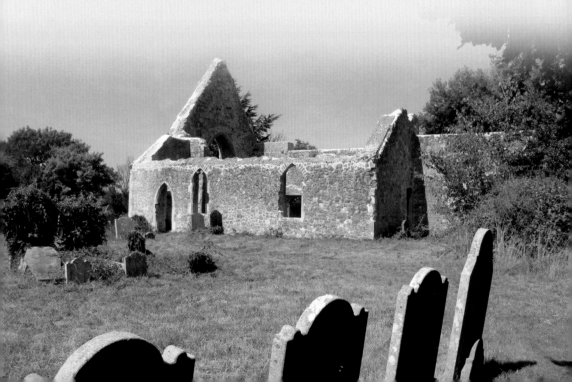

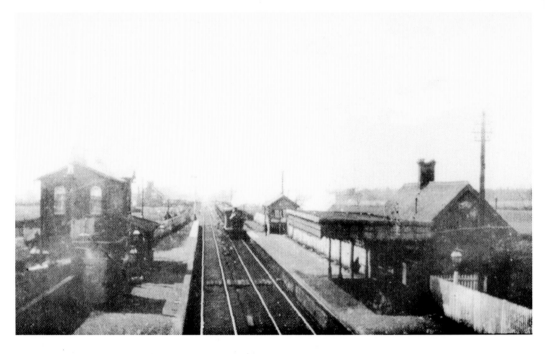

Alresford Station

Alresford railway station was opened on 8 January 1866 as part of the Tendring Hundred Railway Company's new Wivenhoe to Weeley branch line (later extending to Walton). The old station building, which can be seen on the left of the older view, survives in the modern set up, but the signal box and waiting room on the other side of the tracks have been demolished.

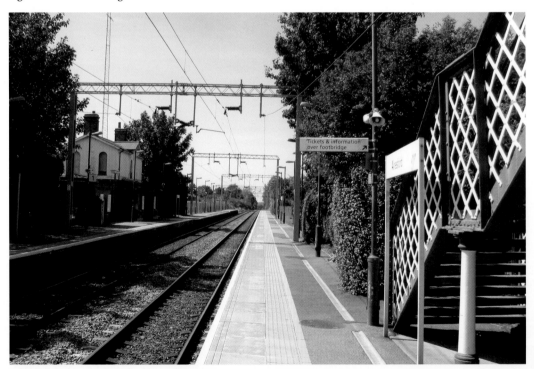

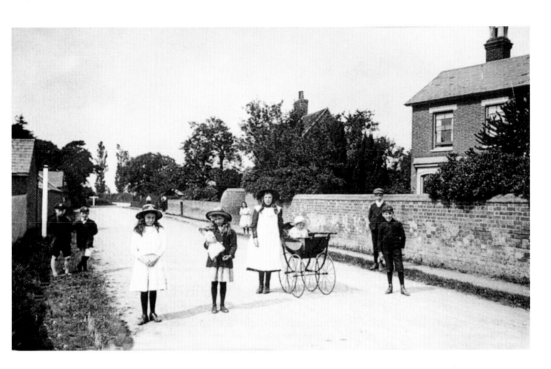

Wivenhoe Road, Alresford

This group of children appear to have taken up fairly precise positions for the photographer in this early view of Wivenhoe Road, Alresford. The house on the right of the picture, known as Crestlands, has since been demolished, although Baytree Cottage (partially hidden behind the trees), survives on the right of the modern view. The Crestlands house was taken down to make way for a new housing estate of the same name around 1970.

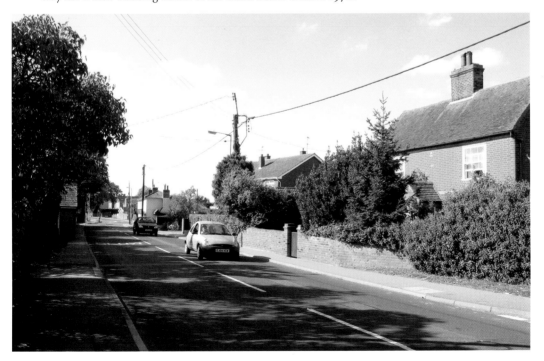

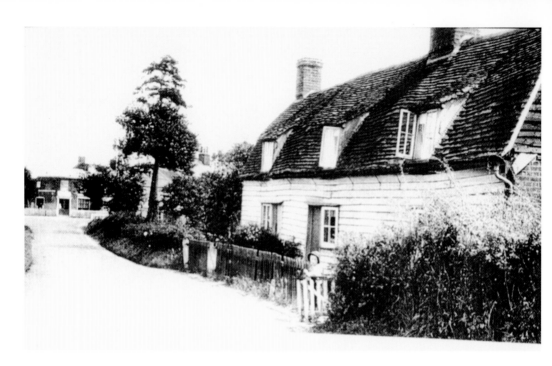

Ford Lane, Alresford

This view of some old cottages in Ford Lane dates from around 1920. The cottages have long since disappeared and the road has been diverted to a new mini roundabout. If it were not for the distinctive building at Mead's Corner, just to the right of the tree in the modern view, the scene would be almost unrecognisable.

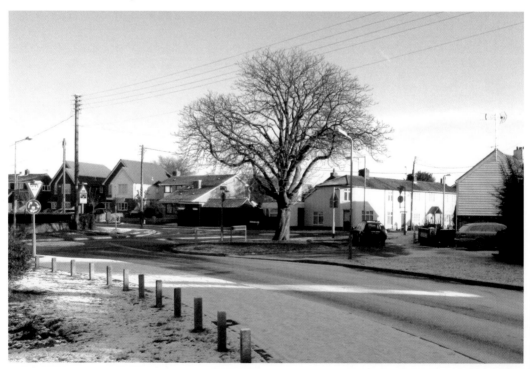

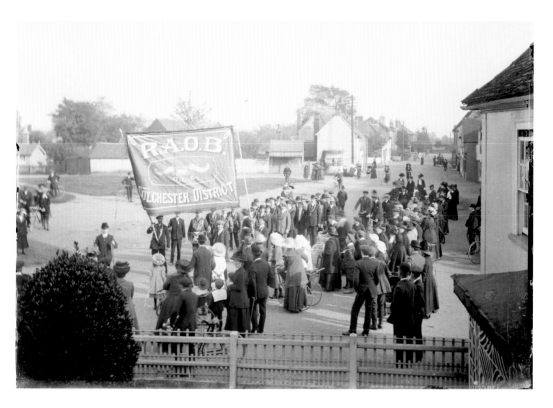

Elmstead Market – Buffaloes' Rally

In this 1905 view of Elmstead Market, members of the Colchester Lodge of the Royal Antediluvian Order of Buffaloes have arrived in Elmstead Market as part of an organised rally. The picture was taken from the corner of School Road looking east towards Frating. The modern viewpoint was taken in 2009.

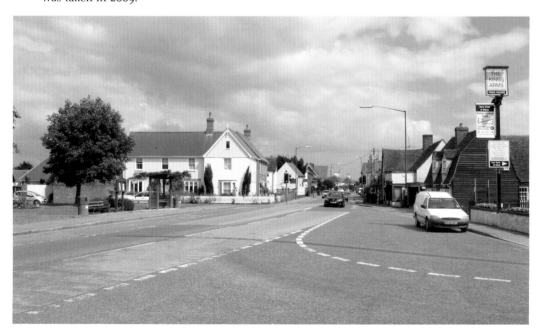

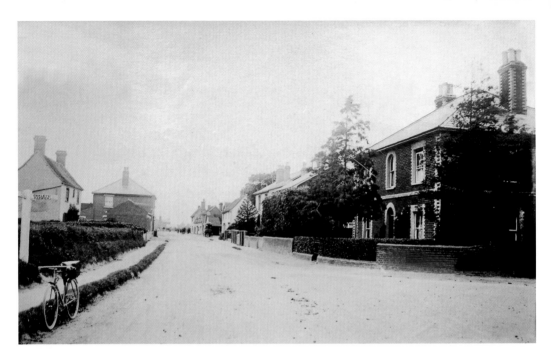

Main road, Elmstead Market

These old and modern views were taken on the main road in Elmstead Market, looking towards Colchester, close to the junction with Bromley Road, as seen on the right. In recent years the village has become famous for its association with Beth Chatto's gardens, which have become nationally famous.

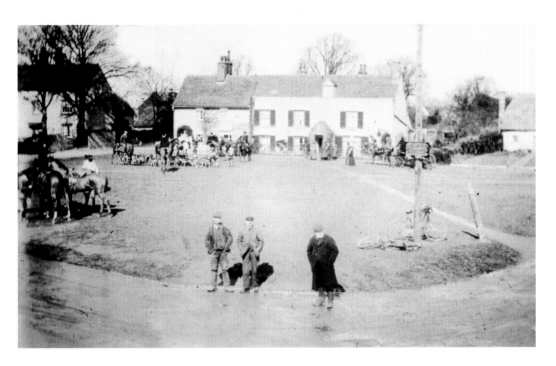

The Green, Elmstead Market

This view of the green at Elmstead Market dates from the early years of the last century on the occasion of the meeting of the hunt. The buildings in the foreground still remain in the modern landscape, although much of the old green area has been incorporated into the modern road system. In former times, the green was used for holding markets and fairs, hence the name 'Elmstead Market'.

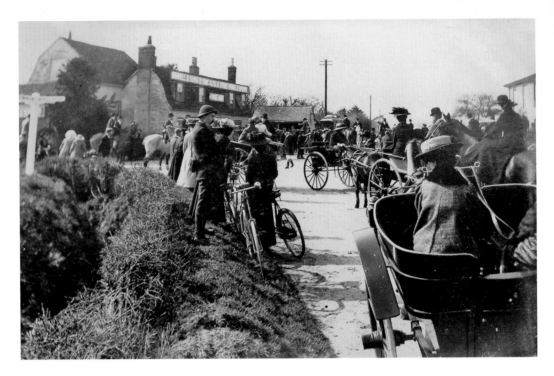

Frating Green

This is another meeting of the hunt, seen at Frating Green in the early 1900s. Note the various horse-drawn traps and carriages in attendance and the lady riding side-saddle on the right of the picture. The King's Arms public house, seen in the background, is still a popular place to eat and drink.

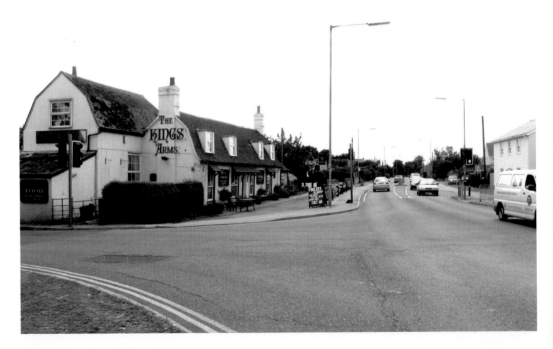

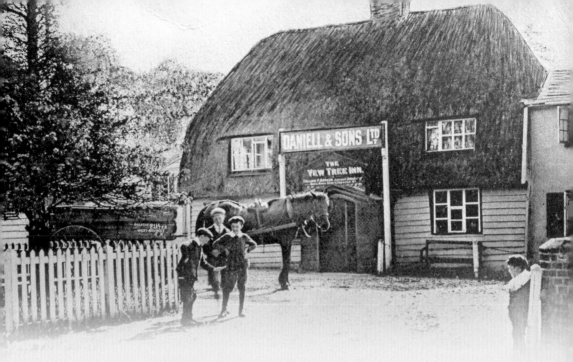

CHAPTER 5

Boxted *&* Great Horkesley

(The Yew Tree public house, Great Horkesley)

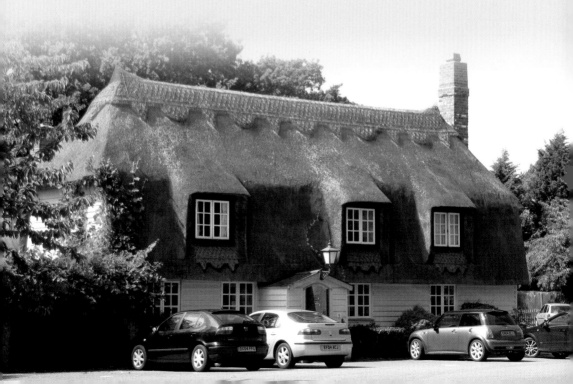

Straight Road, Boxted

An early view of Straight Road, Boxted, looking towards Boxted Cross. Boxted is located about three miles from the northern outskirts of Colchester, with most of that distance comprising this straight section of road leading over the old heath. The lower view shows farm workers gathering in the harvest, sometime during the inter-war period. The picture was taken just a short distance south-west of St Peter's church which can be seen in the background. Note also the horses which were still being used on many farms during this period.

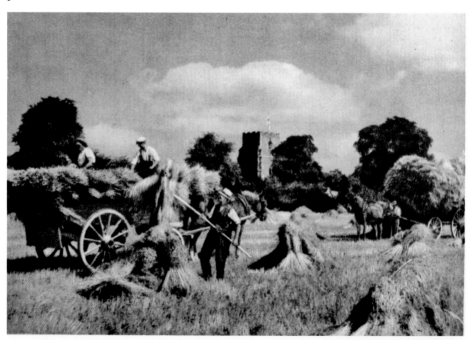

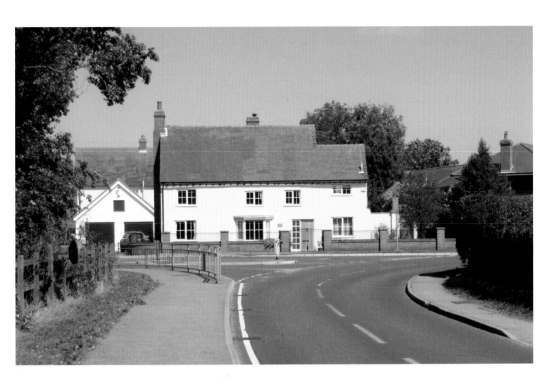

Boxted – The Cross Inn

The older of these two views shows the Cross Inn at Boxted in 1922. The inn, which was formerly known as the Dog and Partridge, was first recorded as such in 1784, although the building itself is thought to date from the late 1500s. Note also the thatched barn on the left, which has since disappeared. Last orders were called at the inn (for the very last time) in December 1987, when this historic drinking place finally closed its doors to the public. The building has since been converted into a private dwelling.

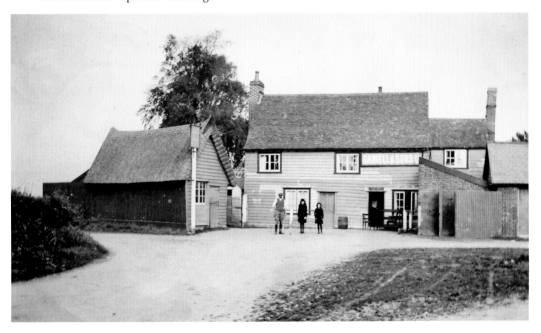

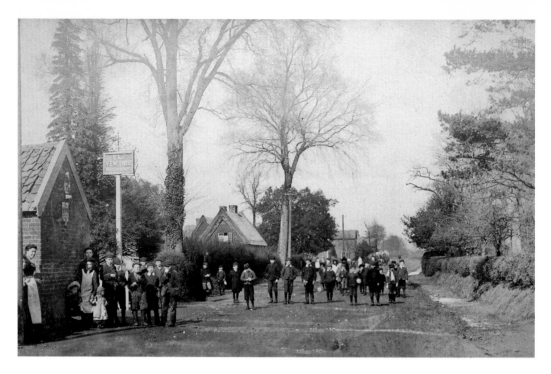

Great Horkesley – schoolchildren

In this view of The Causeway, Great Horkesley, dating from around 1910, children from the nearby school have congregated in the middle of the road to have their picture taken. The photo was taken from a position outside the Yew Tree public house and looking towards Nayland. Such a scene, of course, could never be repeated in modern times without first closing the road to the constant stream of traffic.

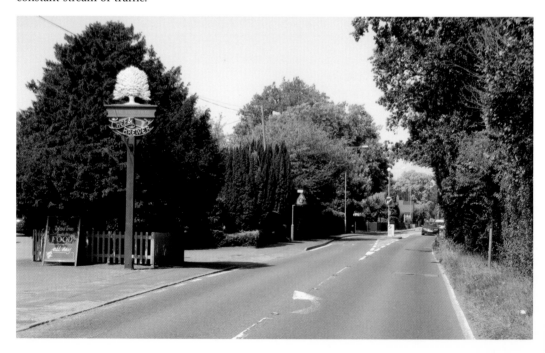

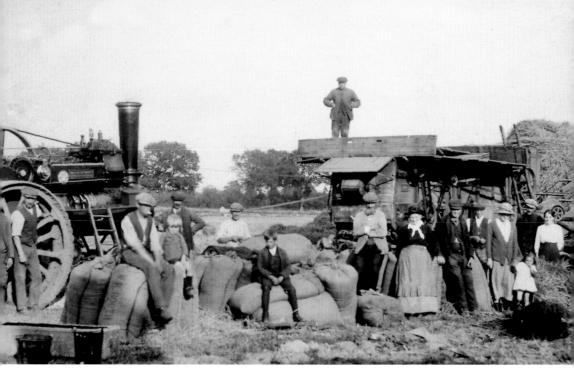

Great Horkesley – harvest workers

Harvest workers take a well-earned breather from threshing work on one of the local farms. The traction engine and threshing equipment was operated by Great Horkesley resident Jimmy Harrington, who described himself in the 1911 census as an engine driver and threshing worker. The business was later carried on by his son Gerald.

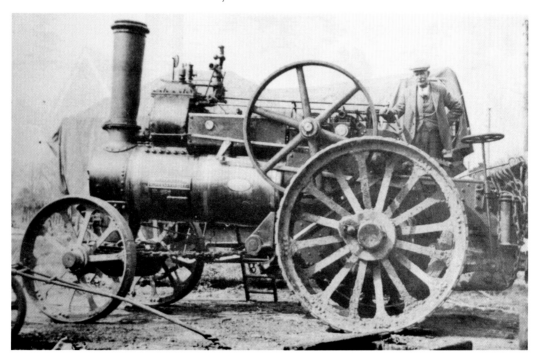

The Causeway

This view of the Causeway was taken in 2009 close to the junction with School Road and the new mini roundabout. The building, just visible in the distance, is the current village hall. The older view of the same scene shows that very little has changed over the intervening years.

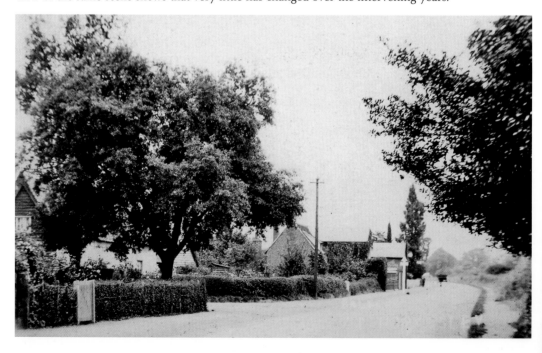

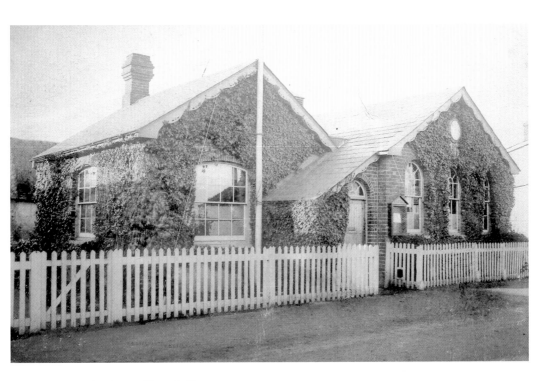

Great Horkesley – village hall

The building, now used as the village hall, began life as a Primitive Methodist chapel. It was built sometime around 1860, although by 1878 it had been converted in to a working men's club. In 1960, the building was leased for a short while to the Royal British Legion, and in 1964, it became the village hall. The modern view was taken in 2009.

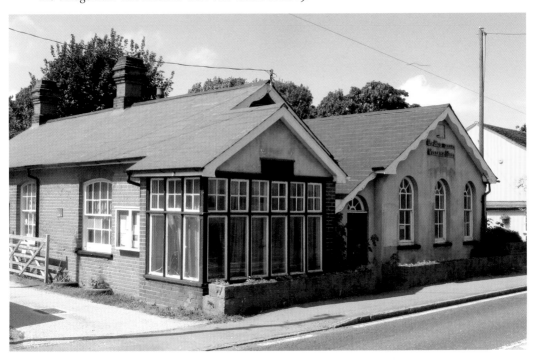

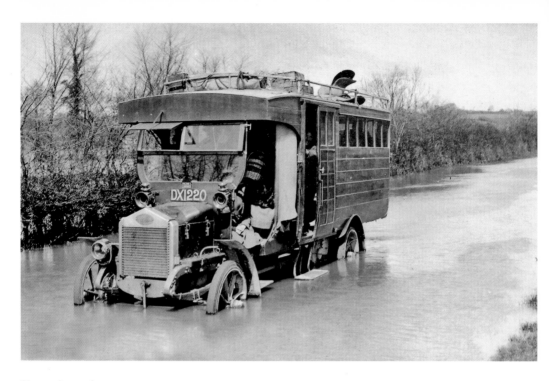

Horse-drawn bus

Here we have two contrasting views of traffic coping with the floods at Nayland in 1919. The top picture shows an early motor bus operated by Skinner's of Boxted at the foot of Horkesley Hill having ground to a halt in the flood water. On the other hand, the lower picture shows that the flood water proved no obstacle for Norfolk's horse bus as it travelled along the same route. The Norfolk family business operated out of Nayland and, on this occasion, the driver was Bill Norfolk with grandsons Les and Stan sitting alongside.

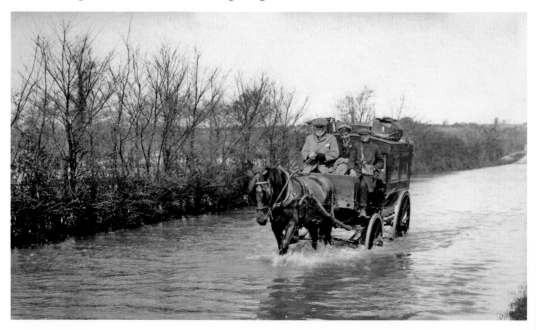

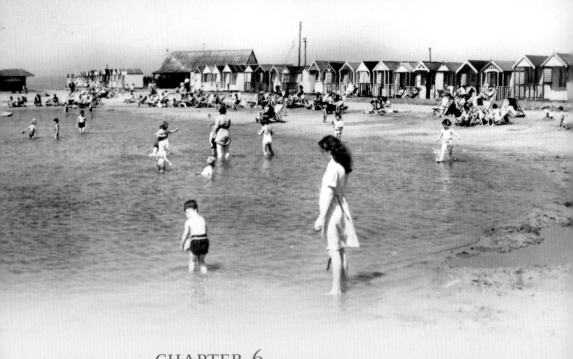

CHAPTER 6

Brightlingsea

(Brightlingsea beach)

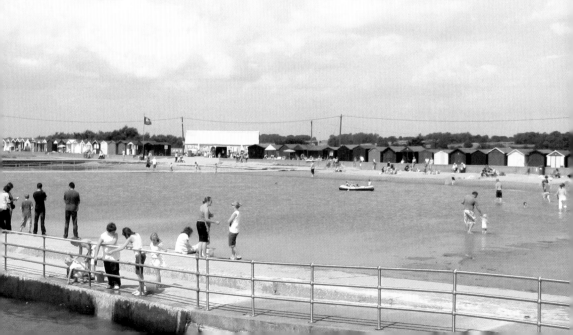

High Street & Victoria Place

An early view of the High Street, taken from the corner of Sidney Street, looking towards St. James' church. The picture would appear to date from 1926, given the fact that the news placard on the corner shop is advertising the General Strike of that year. The modern view from 2009 shows that, apart from the lines of parked cars, very little has changed in the intervening years.

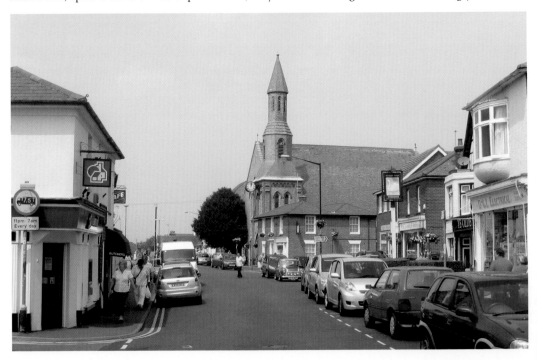

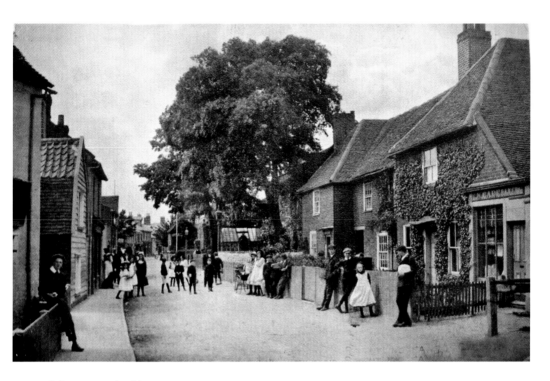

High Street – looking west

In this Edwardian view of the High Street, we are looking west from a position near the junction with John Street. It would appear that everyone depicted in the scene has been carefully positioned to provide the best possible balance to the view. Of course, there were fewer traffic hazards to worry about in those days, but even the modern viewpoint of 2009 has a peaceful and relaxed feel about it.

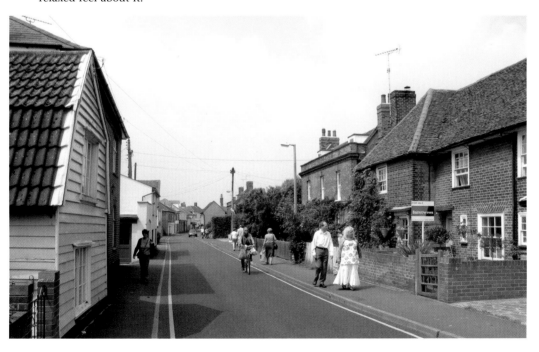

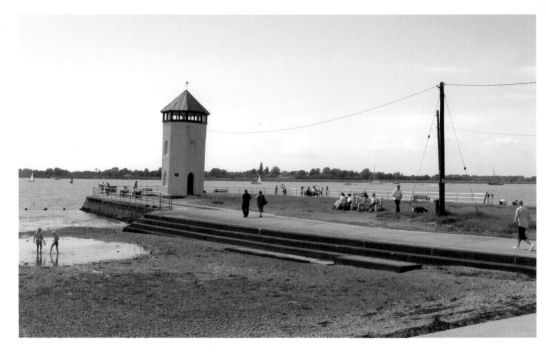

Bateman's Tower

These two views were taken at the end of the western promenade, looking out over Bateman's Tower. The tower was built in 1883 by John Bateman as a place for his daughter to recuperate from consumption. During the Second World War, the tower was used as an observation post by the Royal Observer Corps. Today, the building is used by various local sailing groups from where they can observe and administer races.

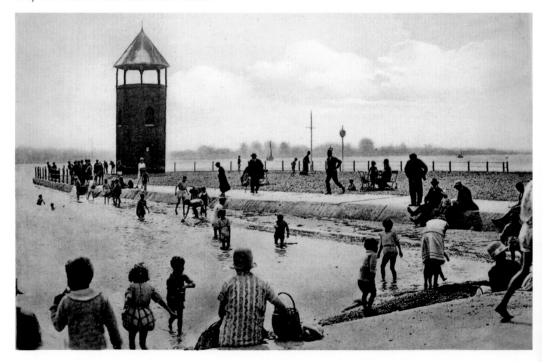

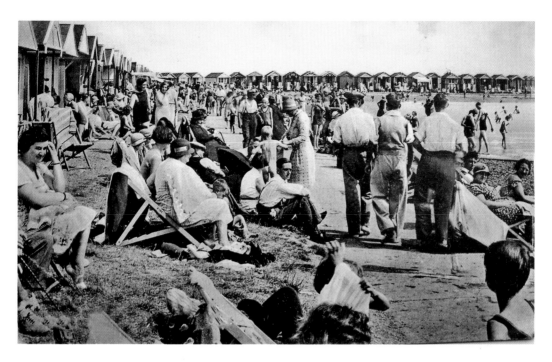

Brightlingsea beach

This crowded beach scene, dating from around the mid 1930s, shows how popular Brightlingsea must have been in times gone by. The huts and promenade are bustling with day trippers enjoying the sunshine. The modern view does seem a little quieter, although the beach huts still remain a popular attraction.

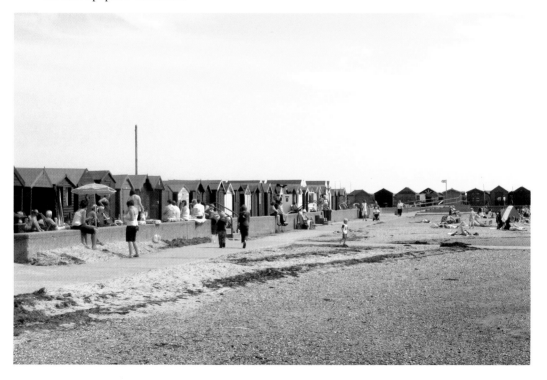

Victoria Place & King's Head

These two views were taken in Victoria Place looking across the main road towards Queen's Street. The twin-gabled building on the left is the King's Head public house, whilst on the right of the picture the old post office can be seen. The earlier view dates from around 1915 and the modern view from 2009.

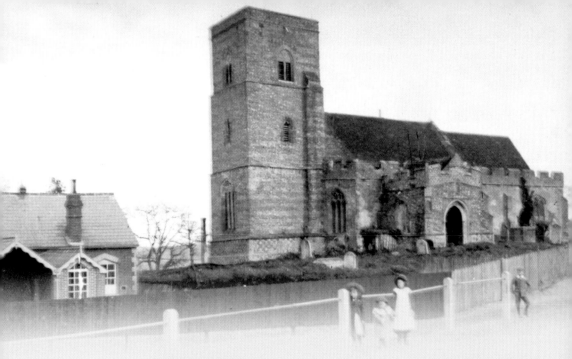

Fingringhoe & Rowhedge
(St Andrew's Church, Fingringhoe)

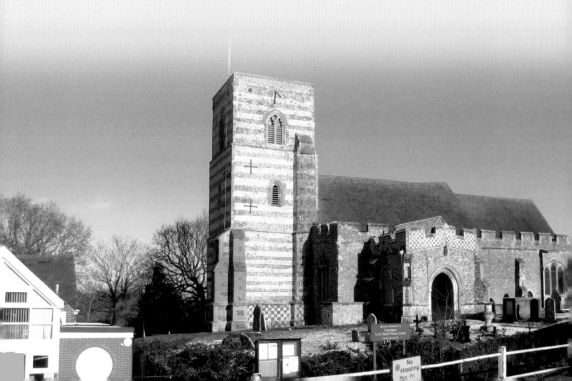

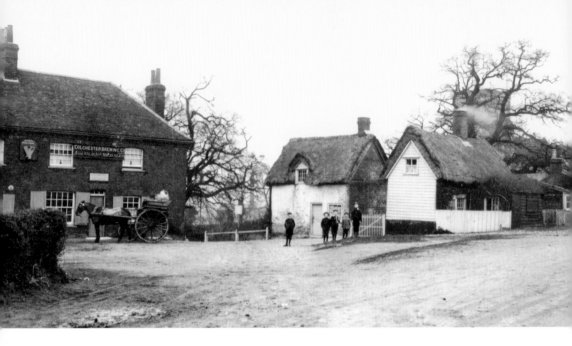

Whalebone inn and cottages

This early twentieth century view of Fingringhoe shows the Whalebone public house and adjacent cottages on Church Green. The inn was first registered by name in 1769, but the building itself may be somewhat older. The thatched cottage on the right with smoke billowing from the chimney has since been demolished, but its neighbour with the small dormer window has been nicely restored. Note the small horse-drawn delivery cart belonging to 'Greenwood & Sons' standing at the front of the pub.

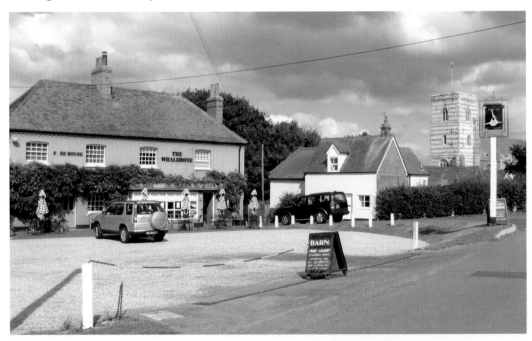

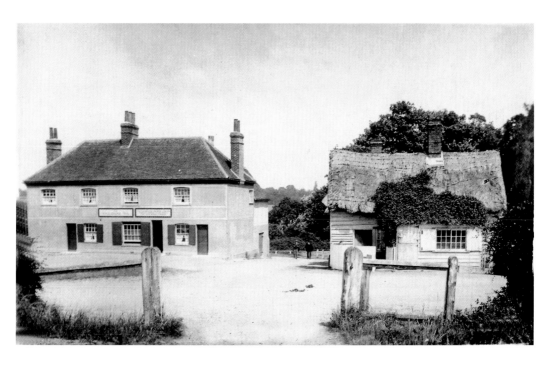

Whalebone corner

Another view of the Whalebone Inn, looking north towards the village pond, behind the cottage on the right. Although the cottage no longer survives, it was once used as a boot and shoe repair shop, and after that a doctor's surgery.

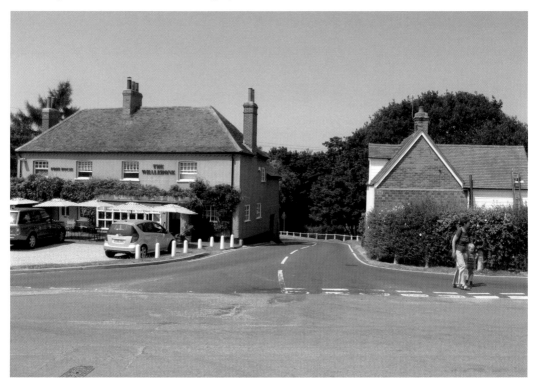

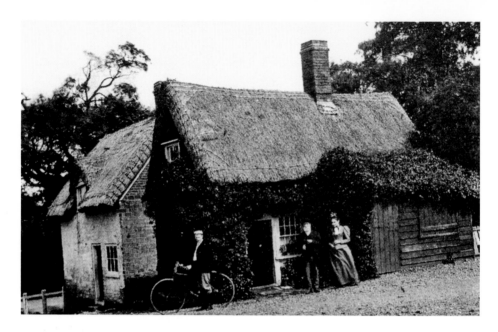

Cobbler's shop

This close up view of the two cottages opposite the Whalebone pub shows the corner building when it was used as a cobbler's shop. The picture would appear to date from the early 1890s when William Durrant was trading here as a bootmaker. According to the 1891 census, he was seventy-one years old at the time and may indeed be the gentleman pictured outside the cottage. By the time of the 1911 census, Thomas Boyston and his wife Louisa had taken over the business.

Doctor's surgery and Connie Kent

In later years, the former cobbler's shop was used as a doctor's surgery. The doctor came across from Wivenhoe and used the former workshop as his consulting room. However, there was no such thing as a waiting room in those days and the patients had to wait outside in the street until they were called in! The small brick and slate cottage on the right of the older view was once the home of a retired actress named Connie Kent, who died in bizarre circumstances. She mysteriously disappeared from the village, sometime around 1939, and it was not until 10 years later that her skeletal remains were found in her bedroom, despite the fact that numerous people had been coming and going into her home over the years.

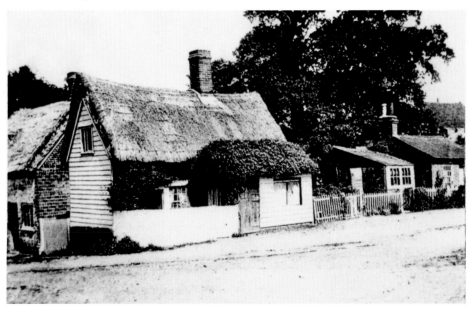

Fingringhoe – Colchester Road

This view of Fingringhoe was taken from a position just below the Whalebone Inn, looking north towards Colchester some two miles distant. The bridge, seen at the bottom of the hill, crosses over the Roman river which runs in an easterly direction before joining the river Colne just below Rowhedge. As can be seen from the modern view, taken in 2010, the landscape still retains its distinctive rural charm.

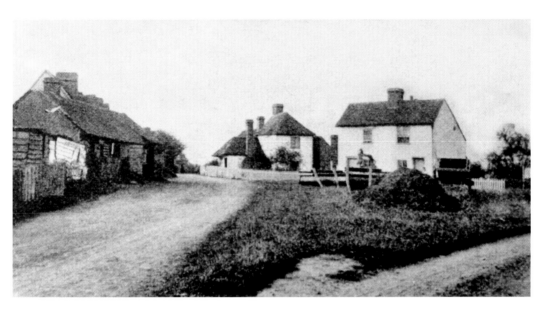

Fingringhoe – Pigs Foot Green

This small triangular piece of land is known as Pigs Foot Green, and the building seen on the left of the older picture was the village forge. The Fookes family had worked here as village blacksmiths for generations before the local horse trade finally gave way to motor vehicles after the Second World War. The old forge was demolished in the 1970s, but an old anvil has been installed on the green as a memorial to this family of blacksmiths. The cottages, seen on the far side of the green, were demolished in the 1930s and the oak tree, seen in the centre of the green on the modern view, was planted in 1936.

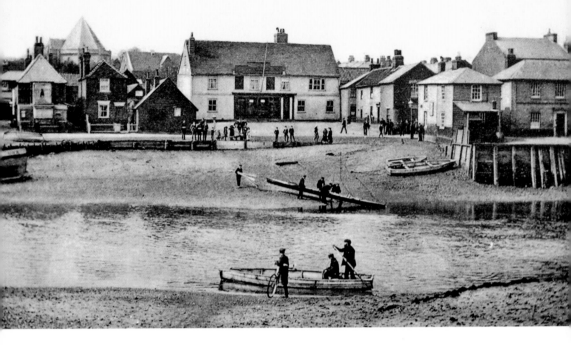

Rowhedge – riverside and ferry

This riverside view, from the early 1900s, shows the quayside at Rowhedge from the Wivenhoe side of the river. The ferryboat can be seen pushing away from the nearside bank, whilst on the far bank a long canoe is being manhandled into the water. The ferry was extremely well used by workers and others crossing between the two communities. The service was abandoned in the 1960s, but in 1992 it was reopened by a group of volunteers on a part-time basis. The ferry now operates at weekends and bank holidays, throughout the summer season, mainly as a tourist attraction.

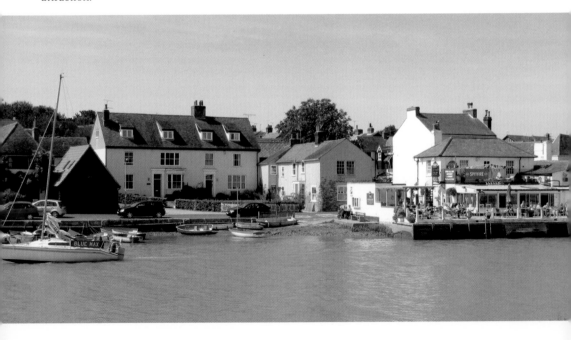

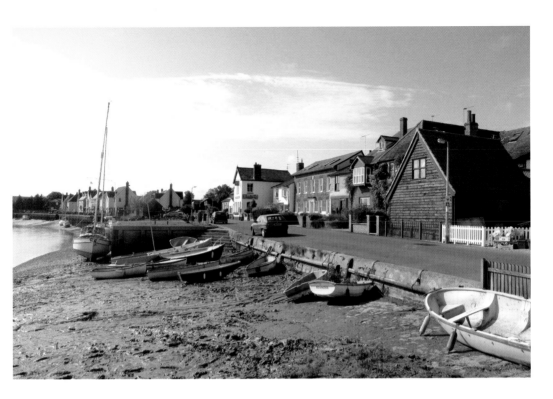

Rowhedge – the quayside

This charming view of the waterfront is looking east along the High Street towards the Albion public house, which can be seen at the far end of the row of buildings on the right. The older view was taken from a position further back along the main street, and shows one of the several small village shops which have all since disappeared.

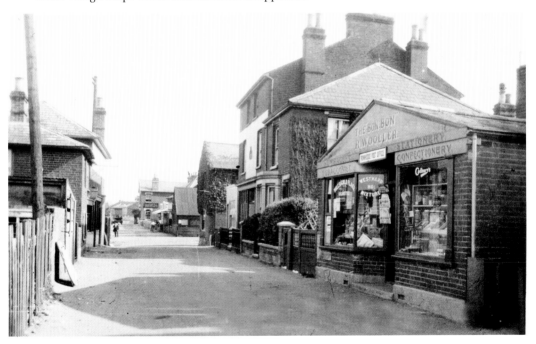

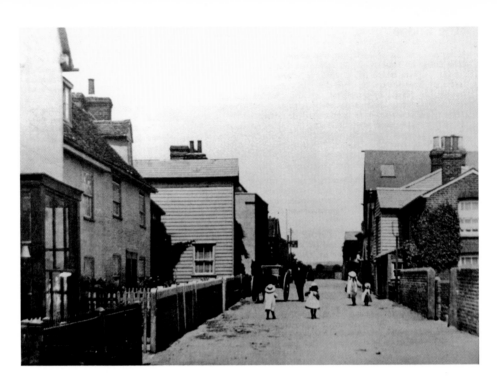

Rowhedge – the High Street

In this view of Rowhedge, dating from the early 1900s, we are looking west along the High Street in the direction of Colchester. The children appear to be in no danger as they play in the street outside their homes. The scene is completed by the presence of a stationary horse-drawn delivery cart and a workman scaling a ladder against a building across the way. The modern perspective, which was taken from a similar position, shows that very few of the original buildings have survived.

Rowhedge – Regent Street

These two views of Regent Street, looking down towards the High Street, were taken about a hundred years apart. In the older view, the street appears to be quite muddy with no properly defined footpaths. The modern perspective, however, shows how times have changed with lines of parked cars and an array of overhead cabling serving the needs of the modern householder.

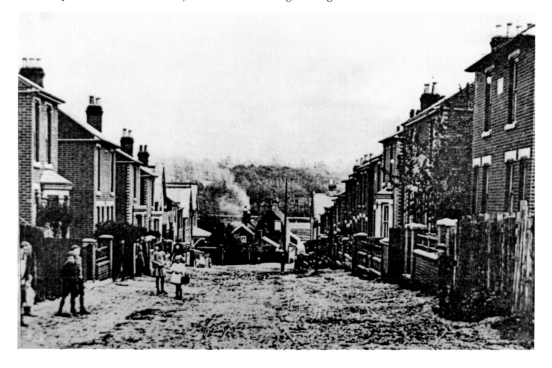

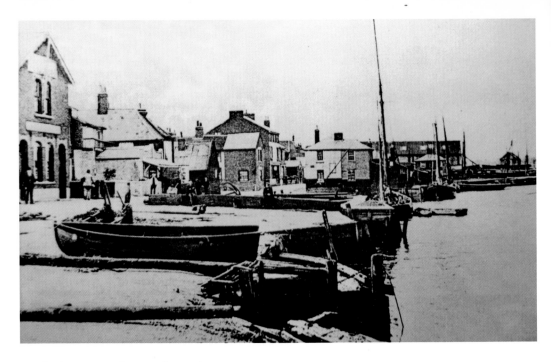

Rowhedge – waterfront and moorings

These two views of the waterfront and moorings are seen looking east towards the Anchor Inn at the far side of the landing area. In the older view, a number of sailing boats and other vessels are seen moored alongside the quay, illustrating the fact that this was very much a working village in its time. The modern viewpoint has a much more relaxed feel about it, inviting one to simply sit and take in the splendid view.

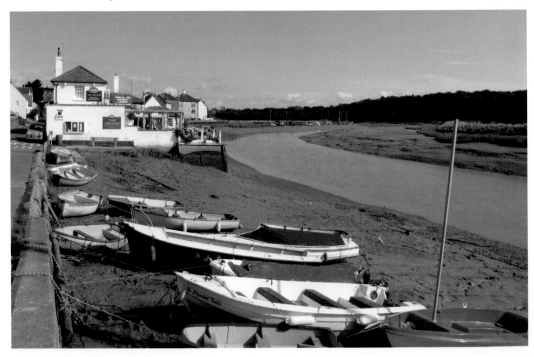

CHAPTER 8

Layer de la Haye

(High Road, Layer de la Haye)

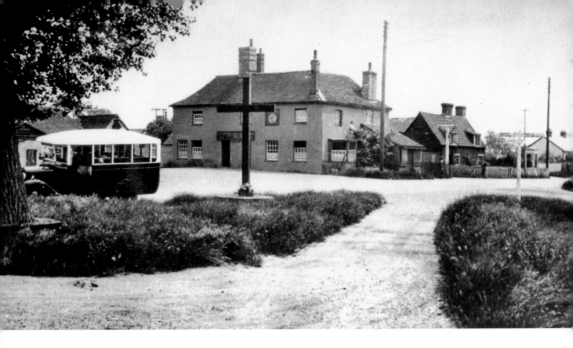

The Forge & Layer Fox

This view, taken from the village green at the Cross, Layer de la Haye, dates from around 1920 and shows the Fox Inn on the far side of the crossroads. A single-decker bus is passing *en route* to Colchester, and note the War Memorial cross in the foreground. The modern view is from 2009, and includes the old Forge garage on the left corner.

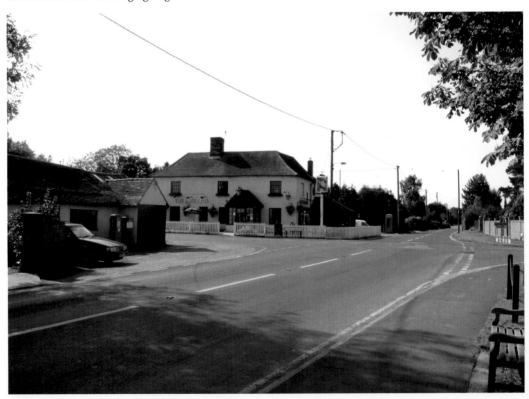

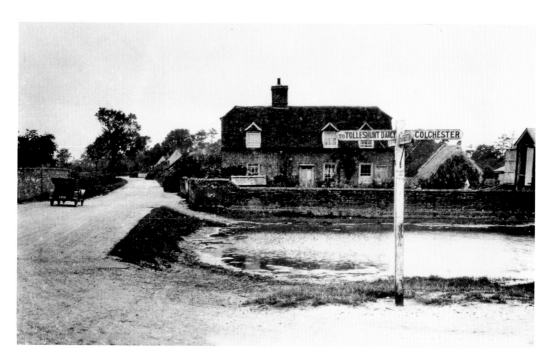

The Cross and village pond

The road to Birch and Layer Breton leads away from Layer Cross past Brickwall farm house, seen in the centre of the picture. Note the thatched haystack to the right of the farm house, and the early 1920s style car on the left of the picture. Note also the village pond which was filled in 1970. The modern view dates from 2009.

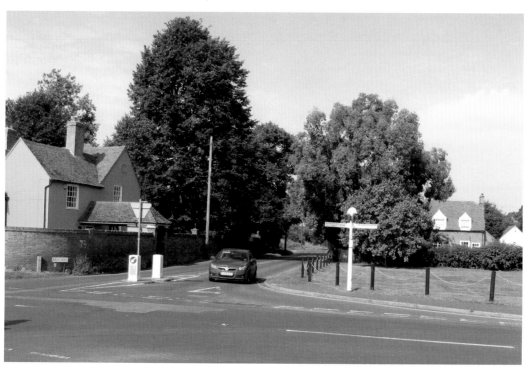

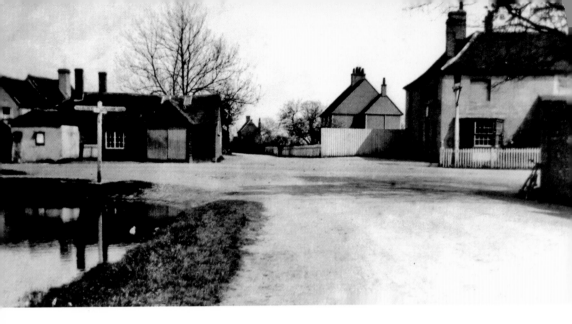

The old forge

In this view of the same road junction we are looking back in the opposite direction towards Abberton. On the right of the junction is the Fox Inn, while on the left corner is the old forge. It is not known when the forge, or smithy as it is often described on old maps, first came into existence but the building itself is thought to date from the 1600s. This picture probably dates from around 1920, shortly before the premises were converted into a garage. The modern perspective was taken in 2009.

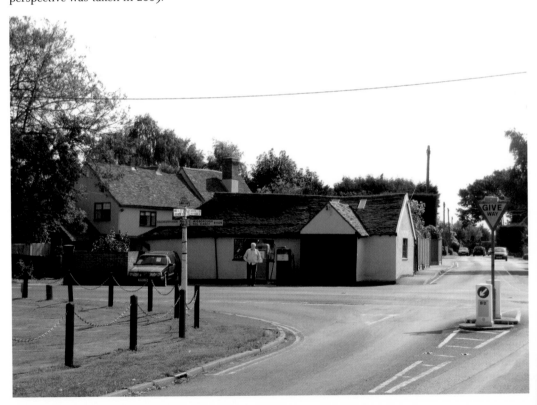

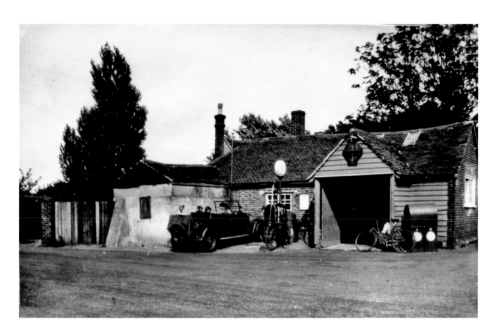

The Forge Garage

This picture shows the Forge Garage as it appeared in 1928. The business was established by Dick Last in 1923, and has remained in the same family ever since. In the 1950s, Dick's nephew, John Morse, began working with him at the garage and today, more than fifty years later, John is running the business. The modern picture shows John standing in his workshop alongside a 1935 Ferguson tractor, a 1937 Austin 7 Ruby and a Francis Barnett motorcycle.

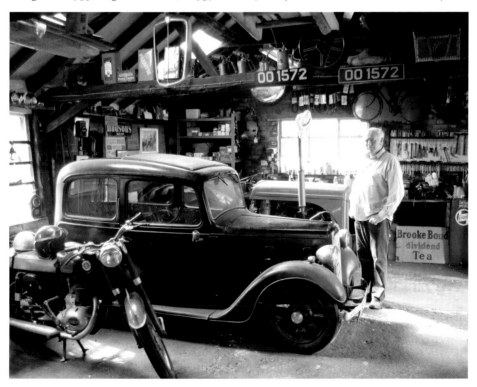

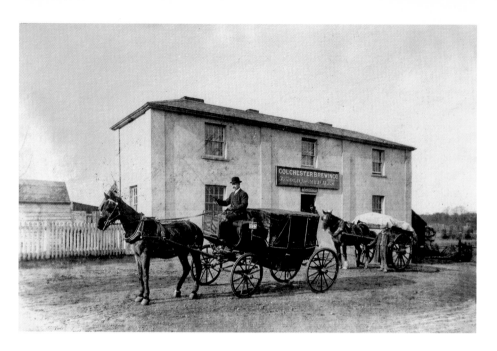

The Donkey & Buskins

A horse-drawn Landau stands outside the Donkey & Buskins public house in this view from the early 1900s. The Landau was a popular form of conveyance because it could be used as both an open and closed carriage, similar in many ways to a modern cabriolet or convertible. The origins of the pub itself date from around the 1850s, when it was trading as a beer house. The story goes that one of its former landlords used to keep donkeys on the adjoining heath, and to prevent the donkeys injuring themselves whilst browsing on the course pasture, he wound strips of sacking around their legs in the form of a soldier's puttees – hence the later change of name to the Donkey & Buskins.

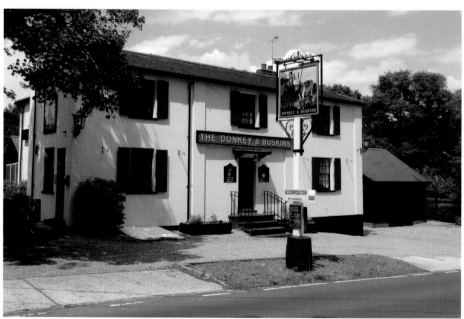

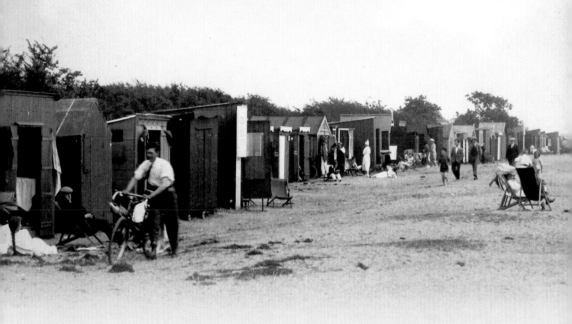

CHAPTER 9

Mersea Island

(Old and modern beach huts at West Mersea)

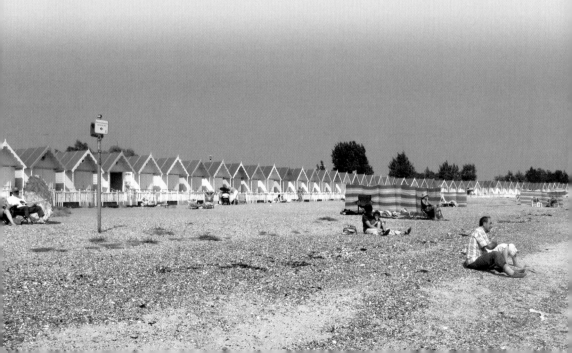

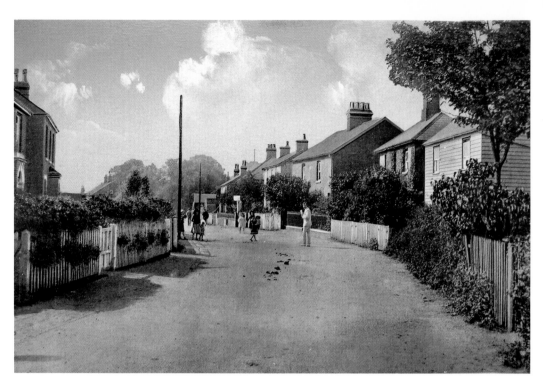

High Street – looking south

This 1911 view of the High Street looks south from a position near the present junction with Melrose Road. Most of the buildings lining the street have since been demolished or converted into modern retail outlets. The tower of the church can just be seen in the background.

The village centre

The centre of the old village at the south end of High Street has seen little change over the years. In the older view, dating from around the 1920s, we can see Mussett's shop on the right with some bicycles leaning against the fence, while further along the road is D'Wit's confectionery store. The male occupants of both of these shops had described themselves as fishermen on the 1911 census and significantly the sign over the entrance to D'Wit's store is still advertising oysters for sale. The modern view was taken in 2009.

The village church

The church of Saints Peter and Paul sits at the heart of the old village and has provided a focus for local life for hundreds of years. The building is mainly of fourteenth century construction, although parts of the tower are believed to date from the late Saxon period. Standing outside the church in the older view is a Great Eastern Railway open-top bus. The company started its motor bus service between Colchester and Mersea in 1905 in competition with Arthur Berry who had launched his own service the previous year. However, the service proved rather unreliable and was later discontinued.

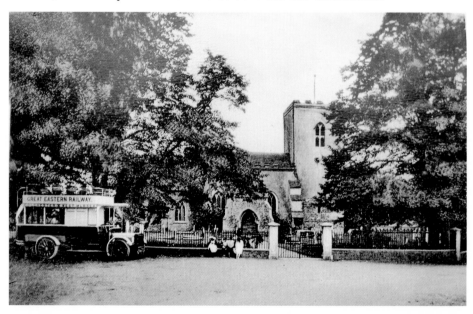

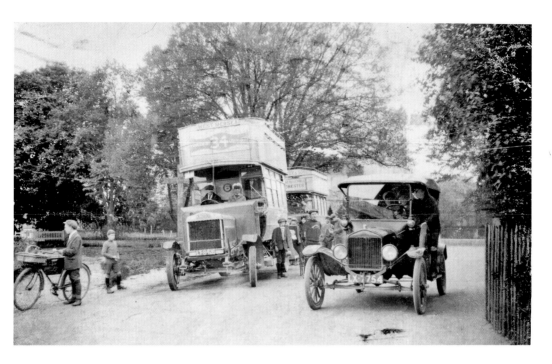

Open-top buses

Two open-top buses, the first a Primrose and behind it a Berry's, are seen waiting for passengers outside the War Memorial in front of the church. The picture would seem to date from the early 1920s and shows how the upper decks were completely open to the elements. Note also the solid rubber tyres which would have resulted in a bit of a bumpy ride. The motor car, seen standing outside the White Hart, is a Model T Ford and was apparently the first motor taxi on the island.

Queen's Corner & Fountain Hotel

These two views were taken in Mill Road looking towards Queen's Corner and the Fountain Hotel. The hotel was built in 1914 as a replacement for the old Fountain public house which was sited further along East Road. The shop on the right-hand corner in the older view was run by Katie White and the car parked outside is an Austin 7, which dates the picture to around 1930. The Fountain Hotel was finally demolished in 1999 and the site given over to modern housing.

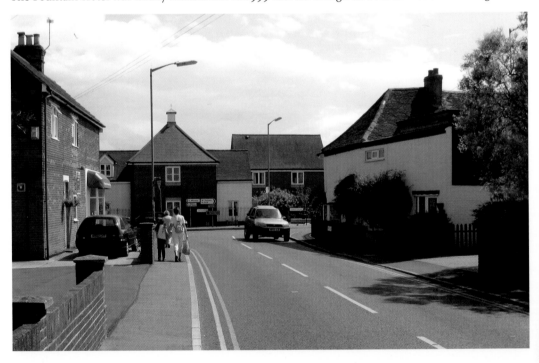

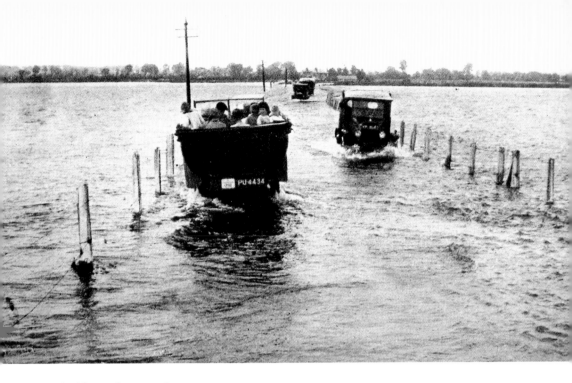

High tide on the Strood

Despite the passage of time, very little has been done to prevent the main road connecting Mersea Island with the mainland from flooding at high tide. The scenes depicted show both the grit and determination of motorists and others to overcome this natural obstacle.

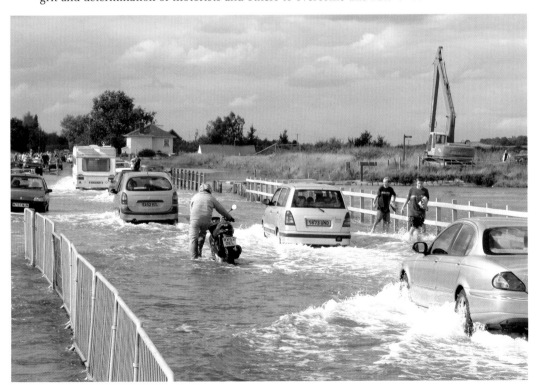

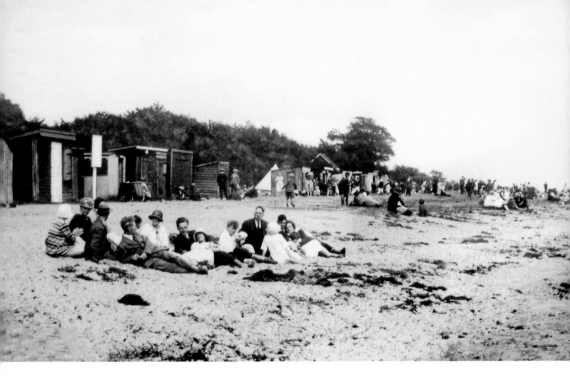

Mersea beach & huts

These two scenes show the beach at Mersea in both the early 1920s and again in 2009. The main difference between the two periods would appear to be in the choice of clothing worn by those enjoying the sea air. In the older view most appear to be quite formally attired, with collar and ties for the men and hats for the ladies. In the modern view things are much more relaxed.

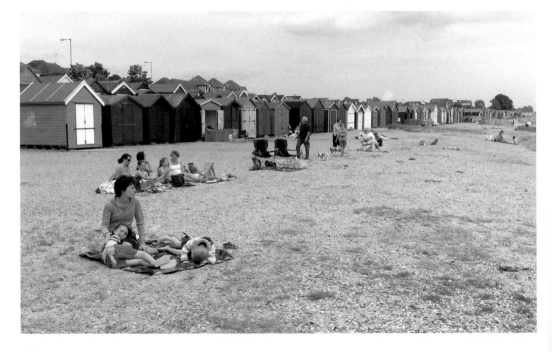

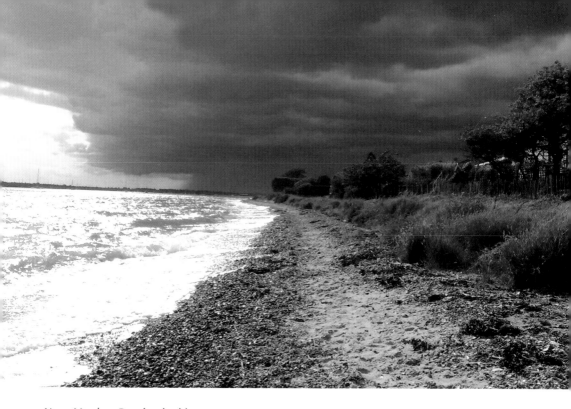

Near Monkey Beach – looking west

This dramatic cloud scene looking towards Monkey Beach was captured in the summer of 2009. The older view of the same shoreline dates from the early 1900s and shows a bell tent pitched just above the high water mark. Tents such as this would often be left erected for the whole season with rents paid to the local council.

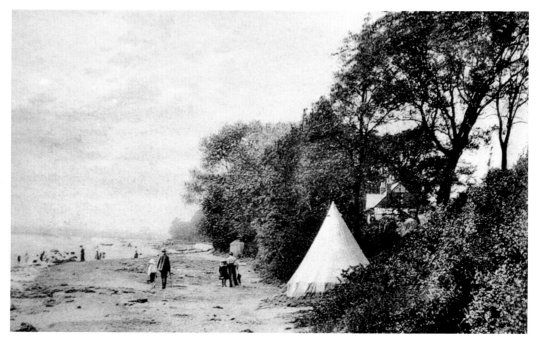

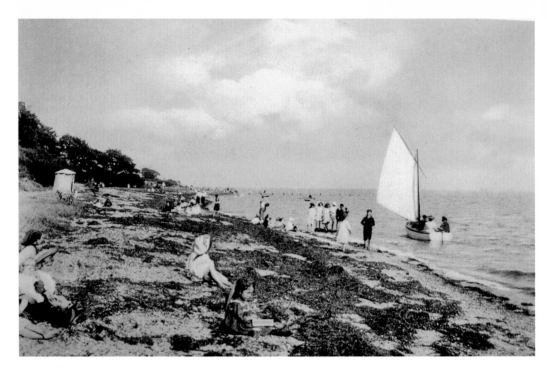

Near Monkey beach – looking east
Another waterside scene from the Edwardian period, looking east from Monkey Beach. Despite the copious amounts of seaweed strewn across the foreshore everyone seems to be having a fun time. This latter sentiment also appears to be the case in the modern view from 2009.

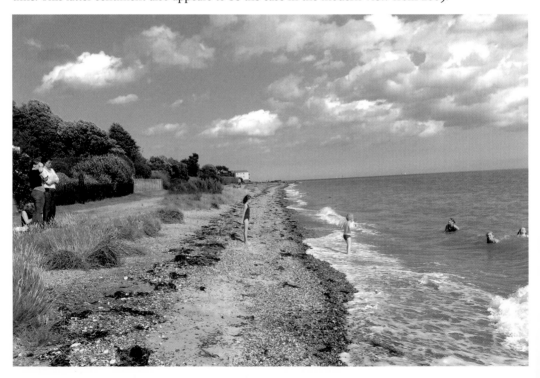

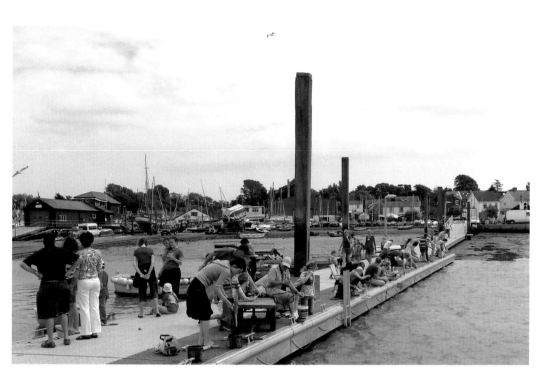

The pontoon

The floating pontoon which has recently been installed at the Hard provides an excellent platform for crab fishing. The original jetty or causeway was reached by little more than a few planks of wood as can be seen from the earlier view from *c.* 1930.

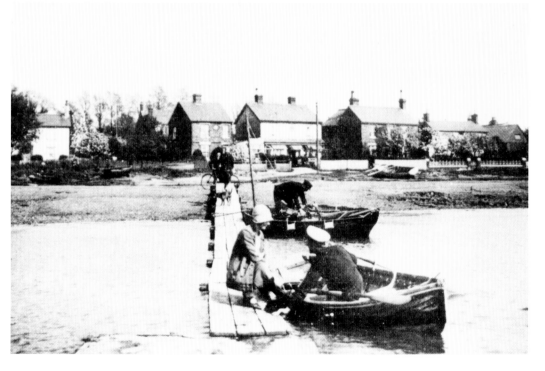

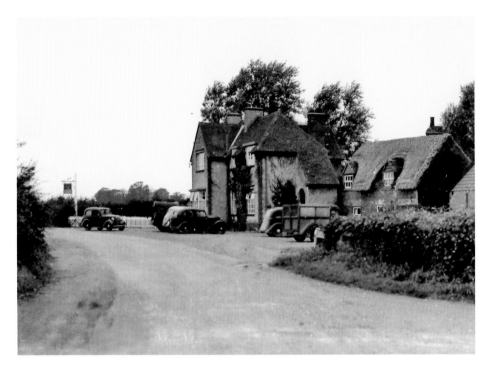

East Mersea – The Dog & Pheasant

The small thatched building on the right of the picture is the old Dog & Pheasant public house, which was replaced in the early twentieth century by the larger building standing alongside. The old pub is said to have once been a haunt for smugglers who no doubt took advantage of its isolated position to avoid the excise men. The old building survived for use as an annexe to the main house and is currently being used as a restaurant.

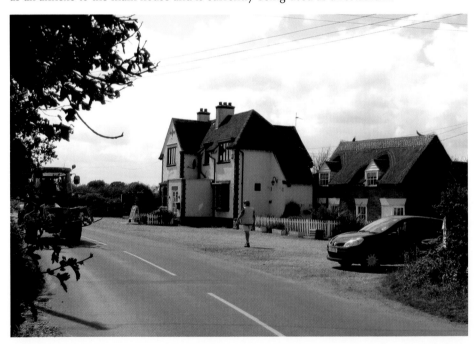

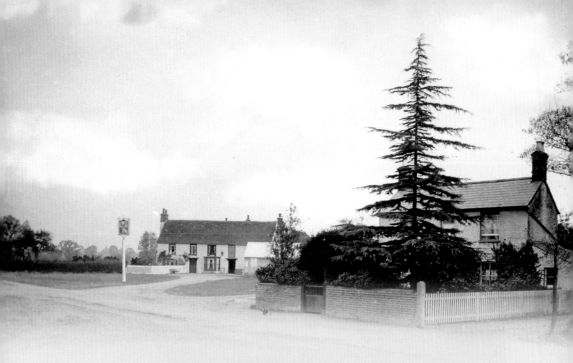

CHAPTER 10

West Bergholt

(The White Hart public house)

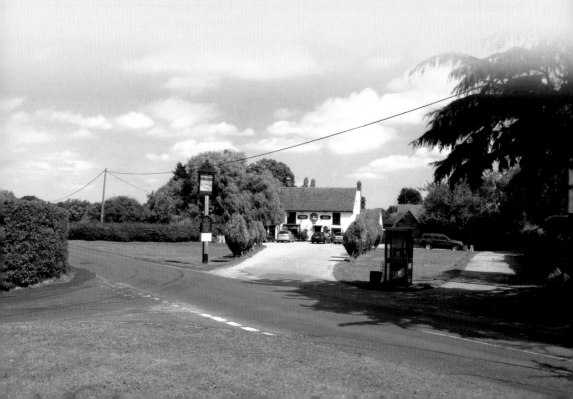

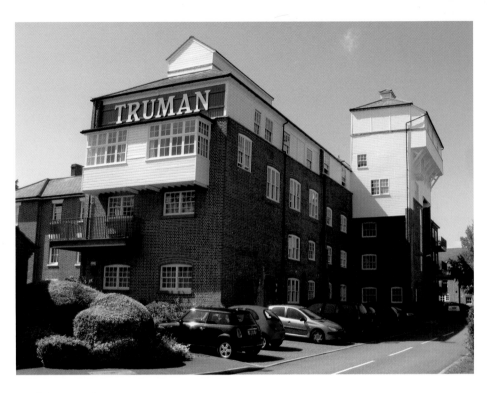

Daniel & Sons brewery

This picture shows part of the old brewery complex which had been an important part of West Bergholt history for over 150 years. The business was founded in the 1820s by Thomas Daniel and continued in the same family until being sold off to Truman's in 1958. In the mid 1980s, the business was finally closed down and, within a few years, the old brewery buildings had been converted into modern housing. The older view, which dates from the late 1920s, shows how the modern conversion has retained many of the original features.

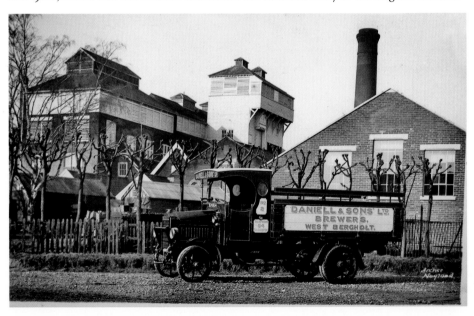

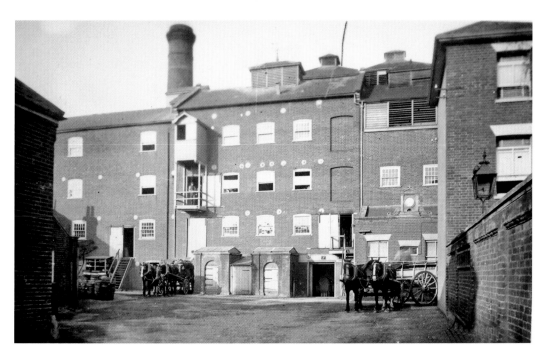

Brewery conversion
Another example showing how many of the old brewery buildings have been retained in the modern housing complex. The older view dates from about 1912, and the modern perspective from 2009.

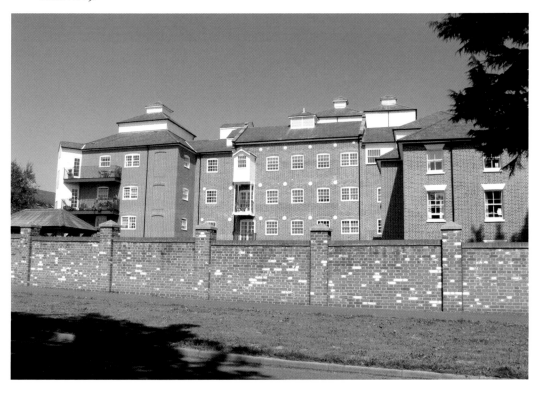

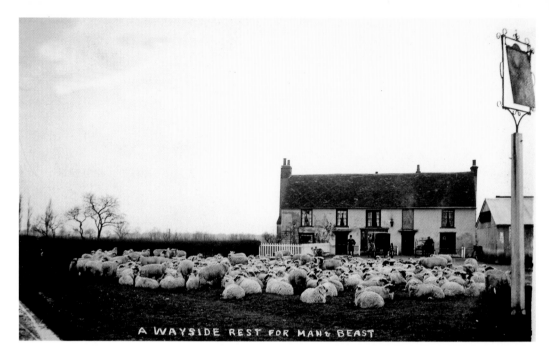

A WAYSIDE REST FOR MAN & BEAST

The White Hart

The White Hart public house stands on the northern outskirts of the village and dates from the early eighteenth century. In former years, the pub was used as a coaching inn and droving station on the road between Colchester and Sudbury. In the view depicted, dating from the early 1900s, a flock of sheep can be seen at rest on the green in front of the pub.

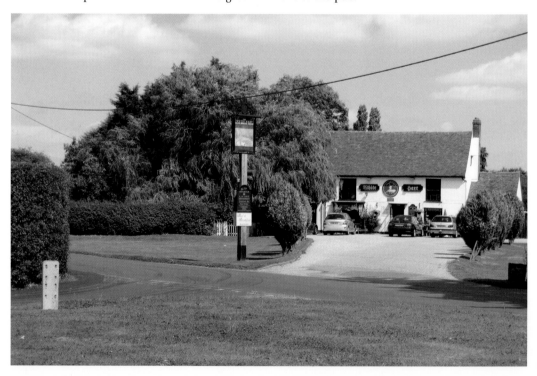

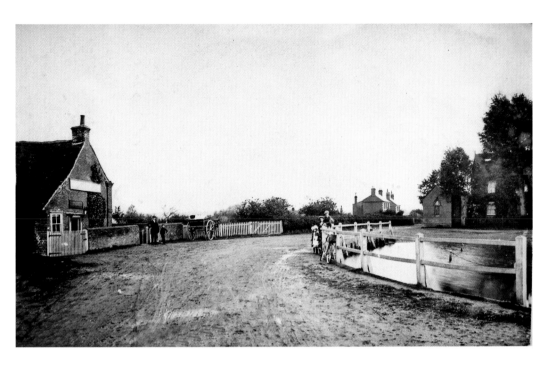

The Queen's Head

This view from 1918 shows the old Queen's Head public house and adjacent duck pond. The pub was one of the many houses owned by Daniel & Sons brewery and is thought to have been in existence for at least 200 years. In the 1950s the building was enlarged and re-modelled into its present format, whilst retaining the main structure of the original building. Today, the pub is as popular as ever and incorporates an Indian restaurant on the first floor.

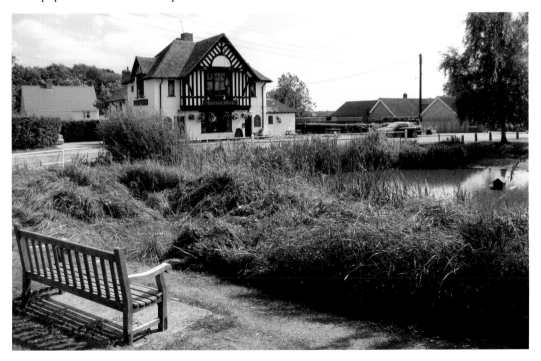

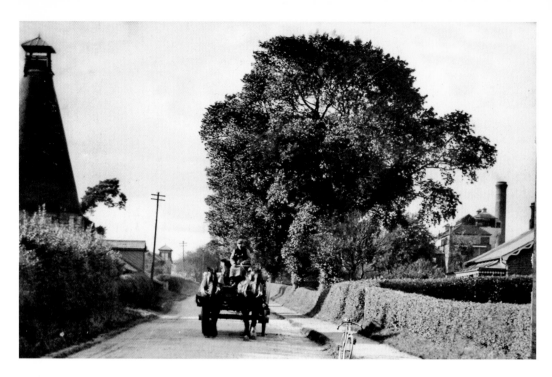

Brewery buildings
A heavy horse-drawn cart (possibly a brewer's dray) is seen making its way along the Colchester road in 1911. Note the malt house on the left and the brewery buildings on the right. The modern viewpoint from 2009 provides another perspective of how the old brewery buildings have been transformed into modern housing.

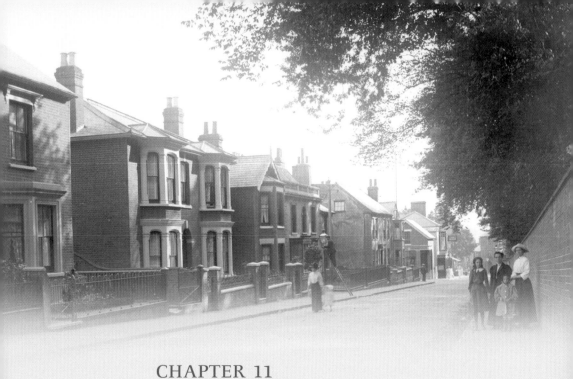

CHAPTER 11

Wivenhoe
(The High Street, Wivenhoe)

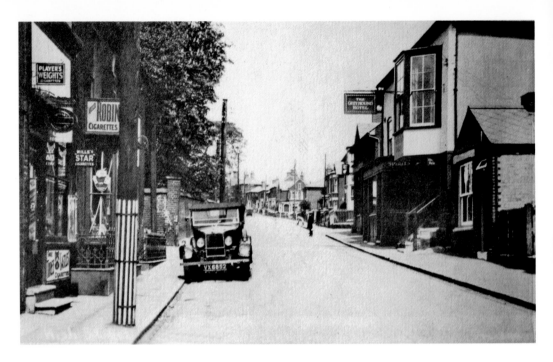

High Street looking north

This view shows the High Street looking north towards The Avenue, sometime around 1930. Note the old Austin 7 car parked on the left of the street and the Greyhound Hotel on the right, which dates back to 1817. Today, the pub is a lively venue hosting such events as folk evenings, live music and poetry readings. The modern perspective was taken in 2009.

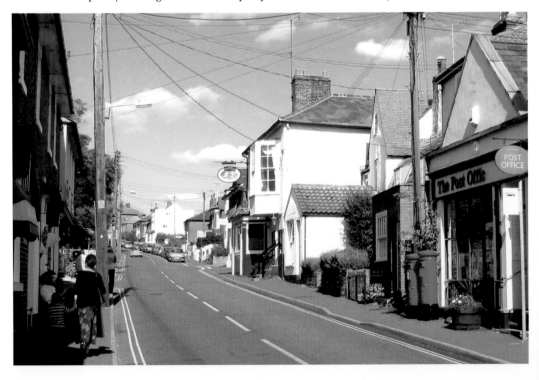

Royal Antediluvian Order of Buffaloes

The High Street looking north, with the railings of St Mary's churchyard just visible behind the parked cars on the right. In the older view, dating from 1905, a large rally of the Royal Antediluvian Order of Buffaloes is seen marching down the High Street and past the church (see also page 35).

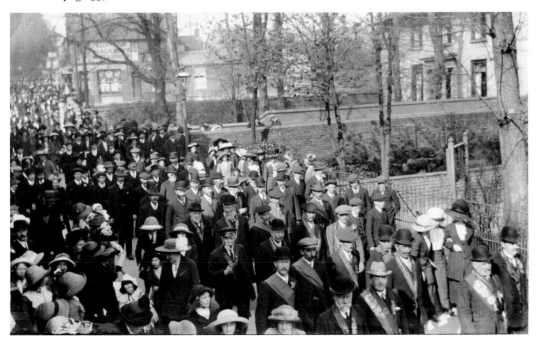

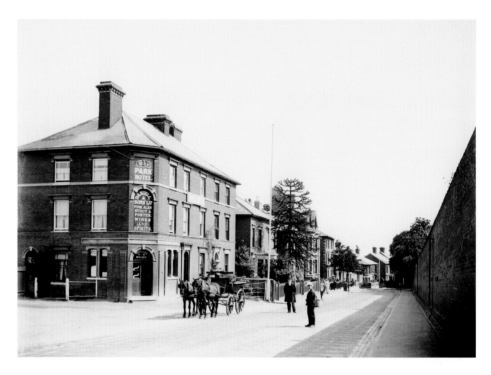

High Street looking south

These two splendid Edwardian views looking down the High Street were taken in 1905. In the first view, we can see the Park Hotel on the corner of Belle Vue Road, with a horse-drawn wagonette or brake standing out front. The hotel was built back in 1863, although when the picture was taken the landlord was Joseph Harlow. The picture below shows a small group of young ladies huddled in conversation in the middle of the street, whilst further down the hill a man can be seen attending to an old gas lamp.

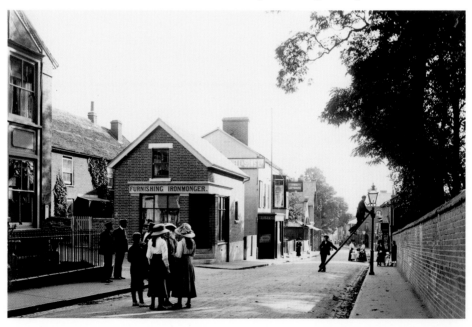

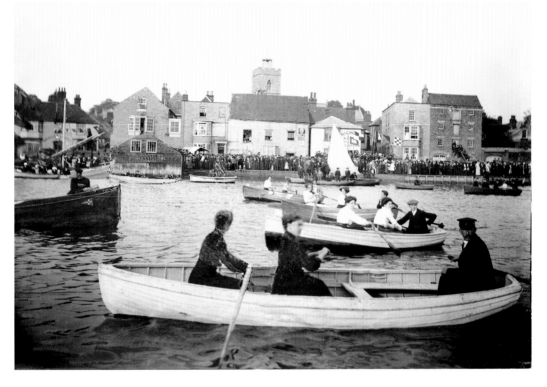

Wivenhoe regatta – ladies' race
This action-packed photograph, depicting the ladies' race at the 1905 regatta, was taken from the Fingringhoe side of the river. The man seen steering the boat in the foreground is George Hillyard, who was landlord of the old Shipwright Arms in West Street. The modern viewpoint from 2009 shows that the waterfront has retained much of its old-world charm.

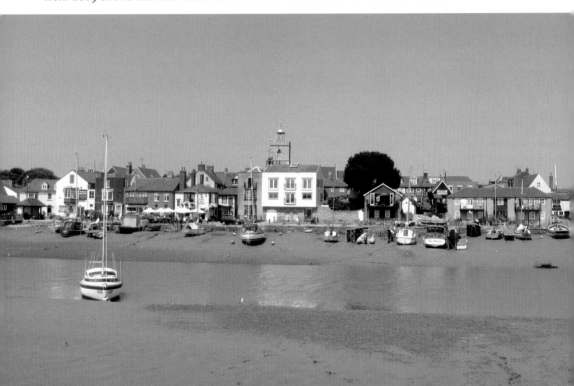

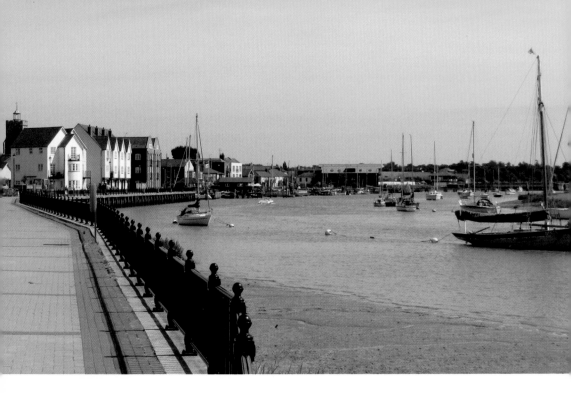

River Colne at Wivenhoe

A modern view of the river Colne at Wivenhoe, looking towards a block of modern housing and the quayside. The older view is another regatta picture from 1905, showing the men's coracle race in progress. Note also the small hut standing on the river's edge, which was used by the ferryman.

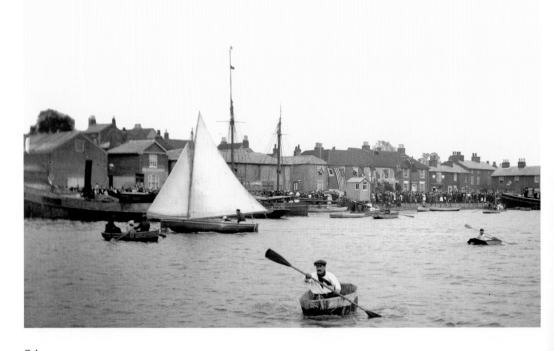

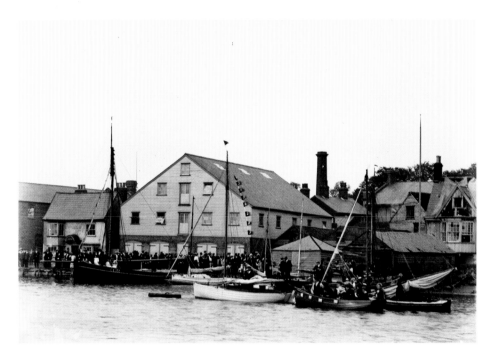

Canning factory

The large warehouse-type building, seen standing on the waterfront, in this view from 1905 (also taken on regatta day), is the old canning factory where sardines and herrings were put through the final packaging process. Sometime after the Second World War, the building was used as a storage facility by Wilkinson & Sons from Tiptree, although in recent times the site has been transformed into modern apartments. The small building, seen to the left of the canning factory, was the Ship at Launch public house, which closed in 1910.

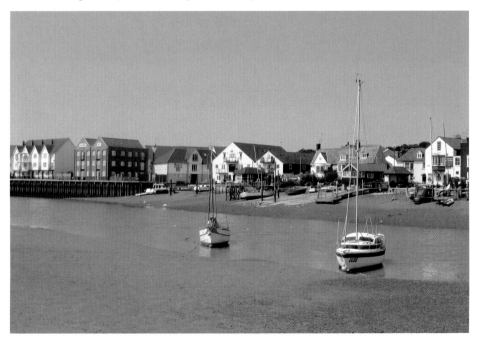

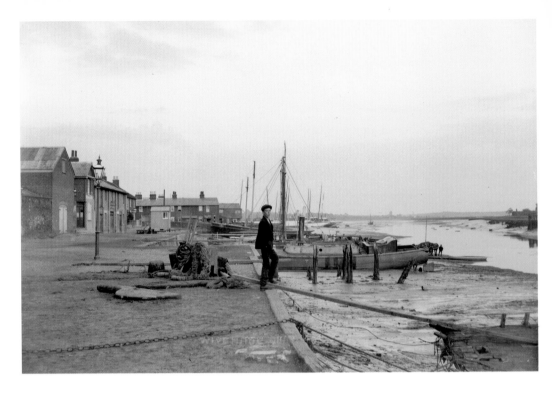

Quayside

These are two contrasting views of the quayside. The older view, taken in 1905, is seen looking downstream towards Brightlingsea, while the modern perspective is looking upstream towards Rowhedge and Colchester.

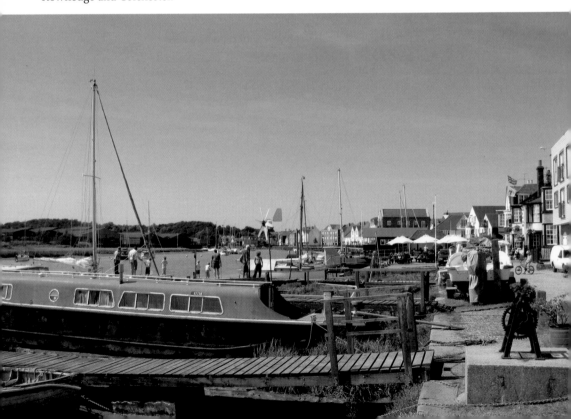